ABANDONED CALIFORNIA

LOST LOCALES OF THE GOLDEN COAST

CLINT REQUA

AMERICA
THROUGH TIME®
ADDING COLOR TO AMERICAN HISTORY

America Through Time is an imprint of Fonthill Media LLC
www.through-time.com
office@through-time.com

Published by Arcadia Publishing by arrangement with Fonthill Media LLC
For all general information, please contact Arcadia Publishing:
Telephone: 843-853-2070
Fax: 843-853-0044
E-mail: sales@arcadiapublishing.com
For customer service and orders:
Toll-Free 1-888-313-2665

www.arcadiapublishing.com

First published 2021

Copyright © Clint Requa 2021

ISBN 978-1-63499-337-1

All rights reserved. No part of this publication may be reproduced, stored in a retrieval
system or transmitted in any form or by any means, electronic, mechanical, photocopying,
recording or otherwise, without prior permission in writing from Fonthill Media LLC

Typeset in Trade Gothic 10pt on 15pt
Printed and bound in England

CONTENTS

ACKNOWLEDGMENTS

My journey across this great state would not have been possible without the support and encouragement of my friends and family. Foremost among those, my fiancée, Ashleigh, is always pushing me to excel in whichever bizarre endeavor takes my interest. She has been a steadfast and entertaining travel companion on my longer sojourns to and from California's various ruins. To my parents for utterly failing to raise the kind of sensible, mature individual who would balk at the idea of climbing a flimsy ladder down a disused mineshaft. To Thomas, Todd, and Andy for just being all-around great. Finally, I would like to thank the fine folks at Fonthill Media for giving me the opportunity to explore so much of California's forgotten history and share it with the world. Compiling and writing this book has been a truly unforgettable experience.

INTRODUCTION

T he sound of the wind roaring through the vacant window frames of the empty lighthouse was absolutely deafening. Abandoned over sixty years ago, the squat, square tower on Punta Gorda still contained a rusting spiral staircase at its heart which ascended steeply upwards through the floor of the lantern room above. Being the intrepid fool that I am, I quickly scurried up to the top of the tower and stood in the center of the lantern, casting my gaze upon the rolling blue waters of the Pacific and contemplating exactly what the hell I was doing here.

Earlier that morning, I had risen from bed before God himself would consider being awake, pulled out of a motel parking lot on the outskirts of Garberville, and begun one of the most needlessly-convoluted day trips I had ever taken. My destination: a place so remote that even the people who built and maintained it left as soon as they thought it was practical to do so. Two hours of babying my truck's fading brakes up and over several sets of mountains later, I pulled into what could well be the loneliest campground on the planet, at the mouth of the Mattole River on the accurately named Lost Coast. I took a few moments to collect my gear and assure myself that I was not about to become hopelessly stranded before capering off down the beach towards the lonely beacon, four miles south of where the road ended.

I am by no means unique in my willingness to put unreasonable amounts of effort and resources into tracking down and exploring empty buildings. Urban exploration, loosely defined as the act of finding and entering abandoned, semi-abandoned or otherwise off-limits man-made structures, has seen a meteoric rise in popularity over the last decade or so. Certainly, a large part of this is driven by social media, the desire to share the experience and prestige of having discovered something which

most people will never see. Other explorers do so for the challenge of accessing locations that are well hidden or heavily secured against unauthorized entry, while still more partake out of a sheer sense of wonderment and curiosity. Whatever the individual explorer's reason, California is a veritable paradise for those clever enough to find what is often hidden in plain sight and intrepid enough to walk confidently into the unknown.

All the unique locations covered between these pages are quite well documented, with all but a few being openly accessible to those who know where to find them. However, they are by no means all that the sun-blasted shores of the Golden State have to offer. Derelict mansions, empty hospitals and rusting theme parks all coexist with expensive condominiums and crowded beaches along California's golden shores.

1

GARDEN OF DECAY
The Story of Montarioso

I t is no understatement to say that the Pacific Coast Highway is one of the most dramatically beautiful drives on the planet. California's Highway 1 winds its way north out of Malibu to join the larger U.S. 101 near Ventura before continuing towards the bustling city of Santa Barbara. The coastal jaunt between Ventura and San Luis Obispo is not quite as breathtaking as the more famous stretch of PCH which meanders through Big Sur to connect the bucolic seaside village of Morro Bay with Monterey, nor is it as engaging to driving enthusiasts as the ribbon of asphalt reaching Northward from the Marin Headlands to Highway 1's terminus in Leggett. Traffic frequently backs up on the southern side of Santa Barbara, giving one ample time to appreciate the numerous oil rigs occupying the Santa Barbara Channel to the west while expensive homes slowly but surely spread across the hills on the east side of the highway.

A casual observer would be forgiven for assuming that there was nothing special to see here. After all, it is an inescapable fact of California's nature that nothing stays empty or unused for long, isn't it?

As a matter of fact, it isn't. Perched high atop the hillsides of Santa Barbara and boasting views which the lesser mansions below it could only dream of, the shell of a fabulous home once known as Montarioso sits in ruin. Montarioso was constructed in 1893 by the creatively named Francesco Franceschi, a brilliant horticulturalist who first introduced many of Southern California's now-ubiquitous flora. Franceschi was an Italian immigrant and world traveler who found Santa Barbara's Mediterranean climate ideal for his beloved plants. Francesco founded the Southern California Acclimatizing Society, a venture which ended in a legal battle between him and his

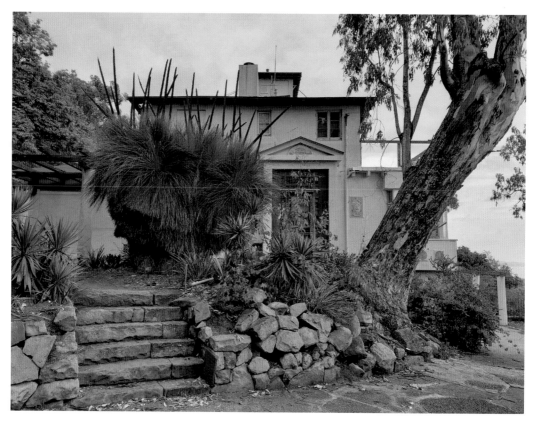

The north-facing entry of Franceschi's imposing Mediterranean villa.

Dutch business partner in 1909. He later founded the Montarioso Nursery in a bid to establish "the first Botanical and Horticultural Institution on the coast of the Pacific."

Francesco accepted a horticultural contract from the Italian government in 1913, leaving California that year and dying in Libya a decade later. Montarioso and its venerable gardens were left in the care of his children, who sold the estate to the wealthy philanthropist Alden Freeman in 1927. Freeman intended that the estate would become a public park and botanical garden, a lofty goal which its founder had also sought after. It was Freeman who remodeled the house from its original Craftsman style to the stucco-clad Mediterranean villa it is today. Plaques and reliefs depicting historical figures and commemorating contemporary events were added to the stuccowork at Freeman›s behest. These unusual artistic touches are by far the most distinct feature of the house. Following these alterations, the house and newly christened Franceschi Park were officially gifted to the City of Santa Barbara in 1931.

By the early thirties, the nation was locked firmly in the grip of the Great Depression, and municipal funding for the upkeep and expansion of Franceschi Park was nearly

nonexistent. Plans which had called for the addition of paths, amenities, and numerous horticultural displays were put on the back burner and ultimately never came to fruition. None other than Francesco's one-time business partner would occupy the home for nearly twenty years, with the City subsequently allowing several other noteworthy horticulturalists to reside in the house for several decades thereafter while making minor alterations to the estate as funding allowed. Through it all, the once-magnificent estate slowly slipped into disrepair.

Though no one seems to have a definite timeline of Montarioso's abandonment, it is abundantly clear to today's visitors that it has been empty for many, many years. Pathways are fenced off and overgrown as the expansive garden slowly invades its creator's home. Windows are boarded up, doors nailed shut, and security systems abound. In 2018, the City Council voted unanimously to tear down the historic structure, citing the seismically unsafe nature of the ruins. Though preservationist organizations and local activists are still working tirelessly to save the picturesque mansion, time is running out.

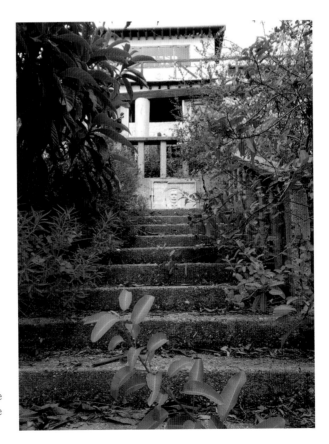

The mansion's front stairs are being slowly reclaimed by the surrounding gardens.

Visitors to Franceschi Park are greeted with spectacular 180-degree views of the Santa Barbara Mountains, the city, the Pacific Ocean, and distant Santa Cruz Island. A narrow, dilapidated path meanders down a gentle slope from the parking area and makes a complete circuit around the exterior of the mansion, providing an excellent up-close look at the intricate medallions and crests sculpted into the walls. Regrettably, access to the interior is now restricted.

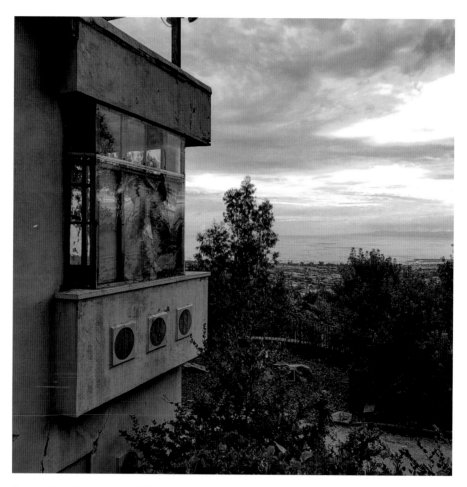

The view from the north side of Montarioso. On a clear day, visitors can see clear across the Santa Barbara Channel. It is little wonder that Franceschi chose this hilltop to build his botanical park.

Above: Some parts of the mansion and surrounding gardens are beginning to crumble as a century of neglect takes its toll. This fantastical arch bridge once connected to an entrance on Montarioso's second floor.

Right: One of the house's strangest features are these plaster frescos. Each of the intricate works of art commemorates a different historical figure or moment of significance.

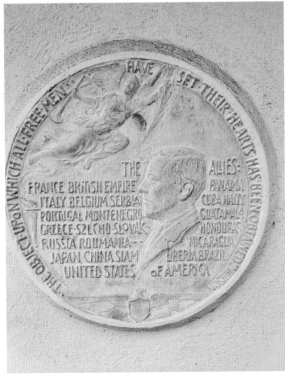

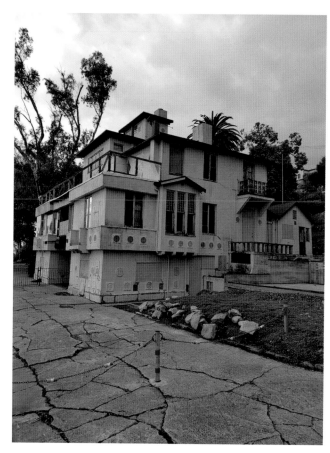

Left: The imposing Mediterranean palazzo has developed a reputation with locals as a haunted house. Between its crumbling facade, boarded-up windows, and untamed gardens, it isn't difficult to see why.

Below: In its heyday, the manor was a spectacular work of architectural beauty. Sadly, its time is now running out. As of this writing, the city has plans to demolish the historic structure.

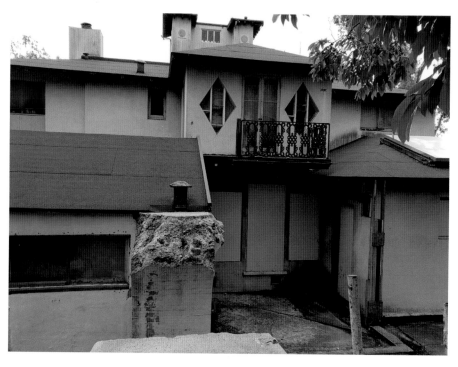

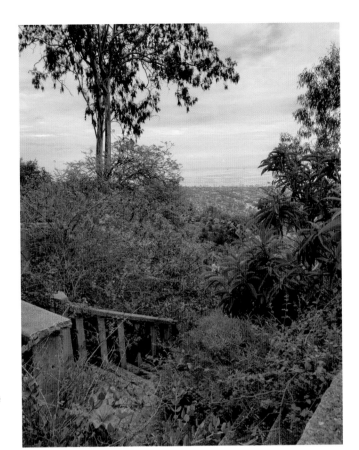

The view from the front of the mansion is unbeatable. With few visitors, owing to its remote nature, Franceschi Park is eerily quiet in spite of its close proximity to a large city.

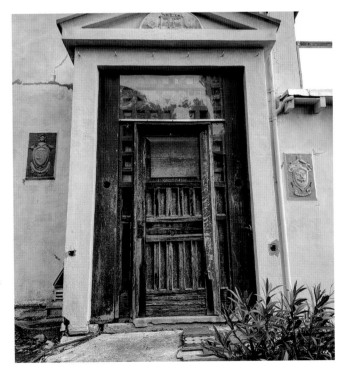

The mansion's front door betrays the house's original Craftsman style. Though popular at the turn of the twentieth century, Montarioso nonetheless retains few trappings of that style today.

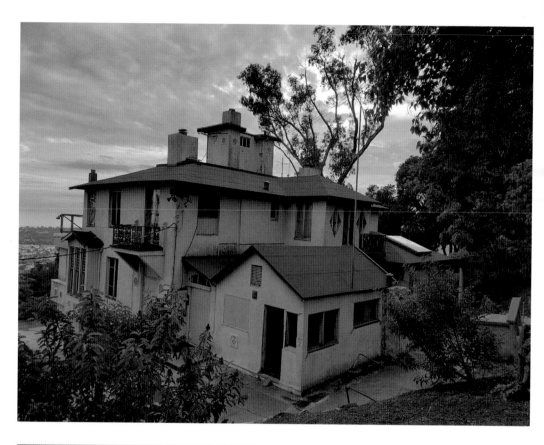

Above: The rear of the mansion. Note the ornate ironwork on the upstairs deck railings.

Left: Another phenomenon common to large estates during the early twentieth century was deeply unsettling statues, such as the one pictured here. These decorations only add to the persistent rumors of hauntings at the hilltop mansion.

2

GHOST OF INDUSTRY
Betteravia

It can be soundly argued that California owes as much of its prosperity to sheer industrial might as it does its geographic beauty and diversity. From the Gold Rush of 1849 to the modern mega-factories of Silicon Valley, the bulk of California's great economic strength lies within its ability to produce staggering amounts of consumer goods, raw material, and, of course, food. Despite water scarcity being a perpetual concern, farms in the fertile Central Valley and coastal regions churn out a diverse assortment of food crops, wine grapes, and staple fibers.

Among the least-celebrated crops historically grown in California is the sugar beet. Until the end of World War II, California led the nation in beet sugar production, with factories springing up all over the state. One such location was the company town of Betteravia. Located on the extreme Northern edge of Santa Barbara County, the town of Betteravia was born in 1897 when the Union Sugar Refining Company established a sugar beet farm and mill on the former Rancho Punta De Laguna.

Ghost towns are decidedly rare on the coast between San Francisco and Los Angeles. At its peak, Betteravia supported a population of over 300 residents, mostly plant workers and their families. Southern Pacific Railroad's colossal SD40 locomotives, belching diesel soot into the salty ocean air and hauling antiquated hopper cars overladen with beets, became a common sight on the coastal rail lines. Crewing the heavy, mechanically outdated, and always overworked trains which traversed the steep, treacherous Cuesta Grade line was a particularly unfavorable assignment. Beet cars were unloaded at the Betteravia factory after being switched from the Southern Pacific rail lines to the purpose-built Santa Maria Valley Railroad. On the land surrounding the factory, a hotel, church, school, post office, gas station,

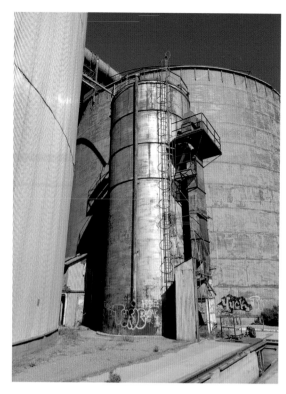

Left: These storage silos and elevator tower dominate Betteravia's skyline.

Below: The factory building has solid bones, but it has still seen better days.

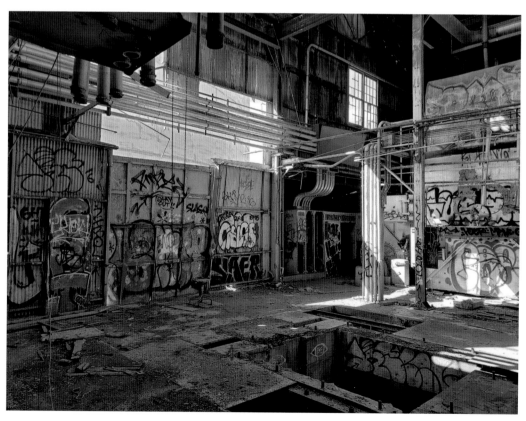

and firehouse complimented the sixty-five houses built for Union Sugar employees, railroad personnel, and their families. Housing was determined by seniority; the stronger a worker's standing in the company hierarchy, the better his standard of living within the company-administered township.

The crown jewel of this miniature city was the factory itself. The towering six-story warehouse and refinery building with an attached metal factory and smokestacks was complimented by two equally enormous hermetically sealed silos. By 1982, this factory was processing nearly 6,000 tons of beets per day. Though the town site included thousands of acres of dedicated farmland supplemented by additional acreage in Guadalupe and Santa Maria, by the latter half of the twentieth century, the bulk of the crop being processed at Betteravia was being shipped by rail from the Imperial and Central valleys.

In the spring of 1988, the factory suffered the only major incident in its ninety years of operation when a dust explosion ripped through the second floor with enough force to blast a sizeable chunk of wall off the building. Eight workers were injured, seven critically. All would ultimately survive the ordeal. The blast started a small fire which was quickly subdued by firefighters, and production recovered quickly.

By the late 1950s, Union Sugar had decided that it no longer wished to maintain the aging infrastructure of the town of Betteravia. Workers were given notice to find new accommodations and the houses were auctioned off for an average of $50 apiece. Most were purchased by their own residents and moved off company property, though a few were bought by individuals outside of the company. By 1966, the last residents had been evicted and the few remaining buildings were unceremoniously demolished. The plant itself changed hands when Imperial Holly Corporation acquired Union Sugar and would continue producing beet sugar until demand dropped off steeply in the early 1990s.

At the end of the 1993 season, sugar production at Betteravia ended for good. The brick warehouse and smokestacks were torn down in 1997 and Betteravia became the only ghost town on California's central coast. Today the site is the headquarters of the Santa Maria Valley Railroad. Old railcars in various states of decay rest on the former factory terminal lines. The hermetic silos, metal factory building, and one solitary furnace stack are all that remain of the former refinery buildings. Imperial Holly fleet trucks, trailers, factory equipment and agricultural machinery litter the concrete foundation of the former factory building.

Visitors today will note that Betteravia feels distinctly isolated despite sharing its immediate surroundings with a large metal recycling facility and being adjacent to a relatively busy road. The large buildings isolate the former factory grounds from road noise; within the factory itself, the only noise comes from the sound of strong coastal

winds screaming through the holes in the building›s corrugated walls. Creaking and clanking noises echo loudly through the empty factory as the deceptively solid edifice settles on its century-old foundations. The remaining structures are, for the moment, in no danger of collapse.

What remains of the Union/Holly factory and former town site is now off-limits due to liability concerns. There are many ways to injure oneself here, and the SMVR is well aware of the risks of allowing visitors to run roughshod through the derelict factory or ascend the rusting ladder to the top of the silos. However, visitors find their way here nonetheless; the floors of the factory are covered in plastic airsoft BBs and no surface has been spared by aerosol-wielding guerilla artists. Would-be models and urban explorers brave run-ins with security to snap pictures on the sagging catwalks or in front of long-idle machinery. Even after its demise, it seems people still flock to Betteravia.

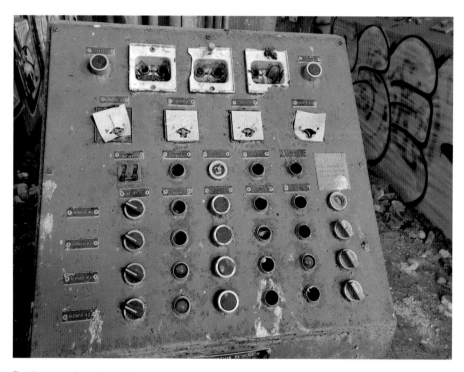

Rusting control panels and decaying machinery litter the factory floor.

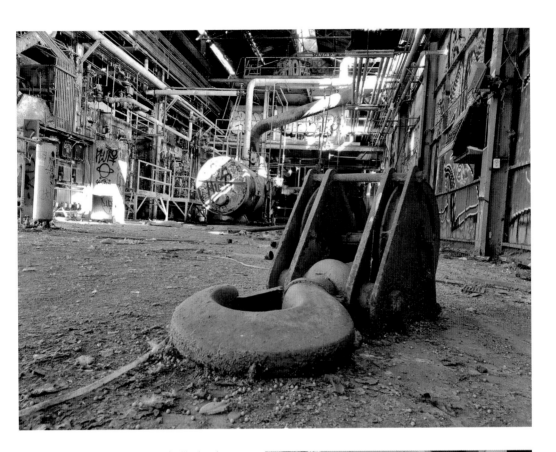

Above: The interior of the facility has been covered in graffiti and is littered with plastic BBs, a reminder of Betteravia's continuing popularity even after its death.

Right: These lift buckets once carried the refined product to the top of the silos for storage.

Positioned in the middle of the factory floor's main level, the purpose of this furnace is unknown to the author.

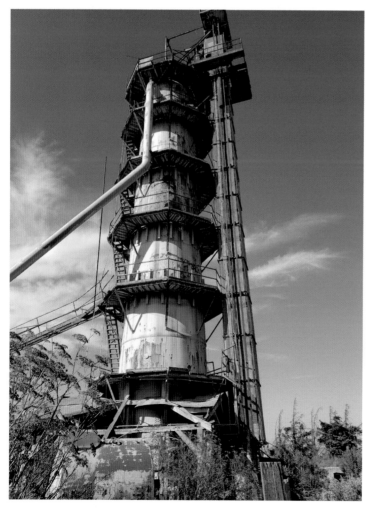

The furnace tower is the most visually striking feature of Betteravia's decimated landscape. Although it appears to be in no danger of collapse, climbing the exterior ladders is still not recommended.

 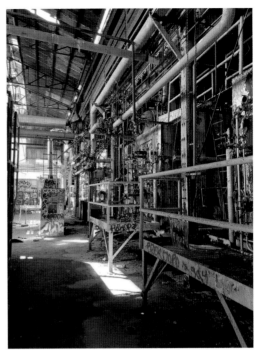

Above left: Much of the company's former fleet is still languishing in a remote corner of the lot. Discarded trucks, mobile homes, farm equipment, and even railcars are scattered haphazardly about.

Above right: Rows of controls and monitoring equipment allowed Betteravia's crew to maintain precise control over the factory's functions.

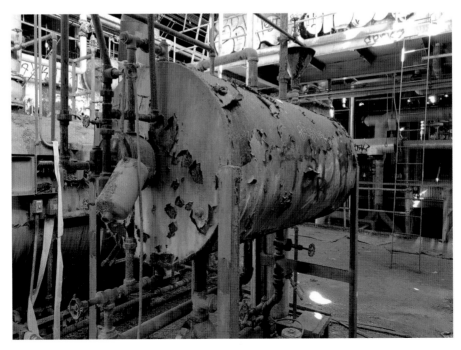

Most of this machinery has seen better days.

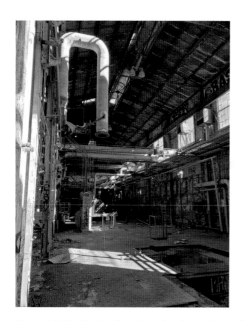 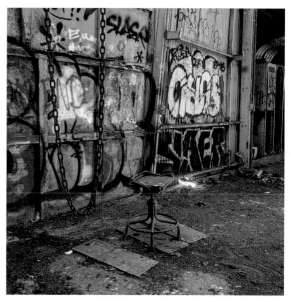

Above left: The factory floor. Note the elevated catwalks towards the rear of the facility.

Above right: The wind ripping through holes in the building sets hanging cables and chains such as this clattering against nearby metal surfaces. Visiting alone can be quite an unnerving experience.

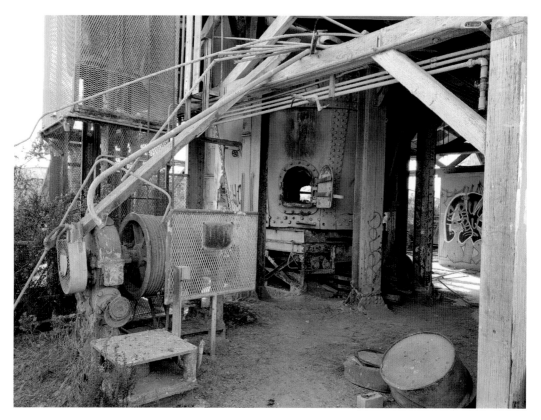

The bottom of the furnace tower.

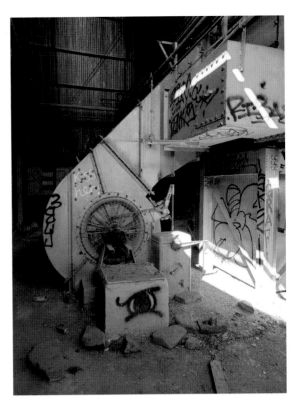

More crumbling equipment.

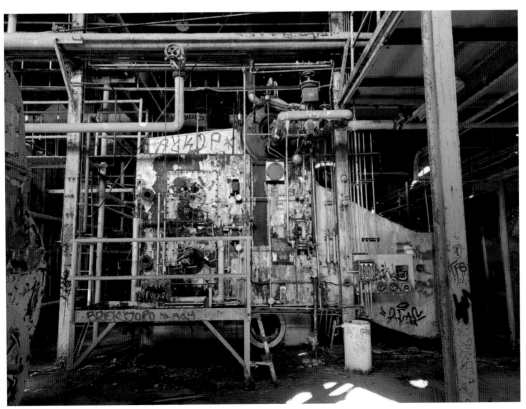

Above left: Following the factory's abandonment, much of the once-vital equipment was simply left where it was.

Above right: Decay is as inevitable as it is pretty.

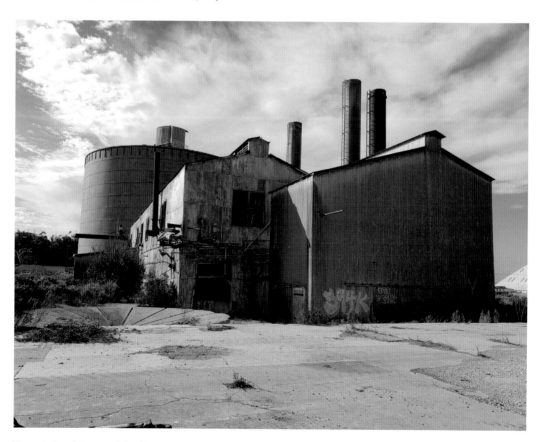

The exterior of the remaining factory building, with the hermetic storage silos in the background.

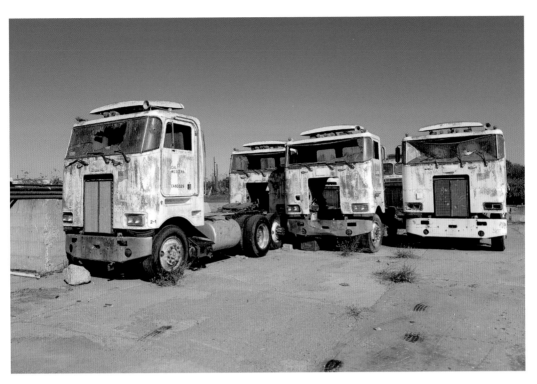

A fleet of heavy haulers once belonging to Union Sugar Corporation now bakes in the hot sun of late summer. Interestingly, the Peterbilt trucks pictured all possess three wiper arms, a trait unique to only one model year.

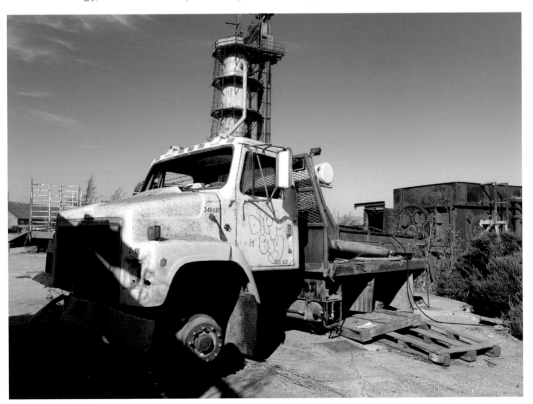

Left: The area at the bottom of these stairs is flooded. However, elsewhere on the factory floor, ladders and stairs lead down to subterranean maintenance passages which are not inundated with water.

Below: Instruction manuals for much of the equipment can be found haphazardly tossed around the workshop adjacent to the main factory building.

These rails were the terminus of the local railway branch at which the hopper cars full of sugar beets would be unloaded. Today many of the tracks are used by the nearby Santa Maria Valley Railroad for storage of unused train cars.

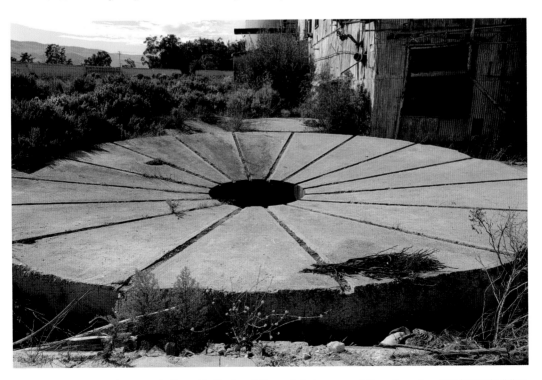

A large hole in the ground, situated in the foundations of what once would have been the main factory building. It likely played a role in the packaging or transportation process of the refined product.

3

A PROMISING FUTURE
Poly Canyon

Located at the midway point between the urban sprawl of Los Angeles and the densely packed metropolis of San Francisco, San Luis Obispo is a once-sleepy college town slowly finding its stride as a hip, upscale destination for the discerning travel aficionado. Once described by a certain celebrity television host as "the happiest city in America," SLO (as locals know it) is home to a dizzying array of attractions including the famed Madonna Inn, notorious "Bubblegum Alley," and a bustling farmer's market which takes over much of downtown every Thursday night. San Luis Obispo, like many of California's coastal cities, began life as a self-sustaining mission village and grew to prominence through its prime location along one of California's most important transportation corridors.

SLO's recent rise to international acclaim has been nothing short of meteoric. Among the innumerable local vinyards, scenic beaches and booming nightlife, a major factor in the town's importance to the state of California is the California Polytechnic State University. Established in 1901, Cal Poly San Luis Obispo is perhaps best known today for its Architectural Design and Environmental Engineering College. Each spring, students from the celebrated architectural program gather at Poly Canyon to put their theories and designs to the test. Since 1963, twenty permanent structures (and countless temporary ones) have been erected, in some cases housing the students responsible for their creation for varying periods of time.

Arguably the best-known of these groundbreaking wonders of engineering is the spacious Shell House. The first building to be constructed using shotcrete, the innovative home was designed and built between 1963 and 1964 by students Larry Gangwisch, Ronald James, Raymond Ketzel, Roger Marshall, David Wright, and

The entrance to Poly Canyon is marked by a distinctive stone archway.

James Zimmerman. Their masterwork of experimental engineering owes its shape (and its name) to a highly specialized technique employed during construction. Liquid concrete was sprayed over metal cables that had been suspended from a central pole, which was then removed after the concrete set. The striking result is a building appearing almost organic at a distance, like a massive seashell plucked from the back of an ancient leviathan and left to stand juxtaposed against a bucolic background of oak-speckled hills, oddly at home in its picturesque surroundings.

Across the canyon, half of a suspension bridge juts forth from the edge of a shallow, grassy ravine above a rusting geodesic dome. Everything here is as innovative as it is bizarre, each design uniquely unusual and yet not at all out of place. As abandonments go, Poly Canyon feels unusually welcoming to the uninitiated visitor. A nondescript half-mile dirt road winds past recently constructed student housing to a stone archway marking the entrance to this well-concealed wonderland. In recent years, the area has become a popular day hike among both students and locals.

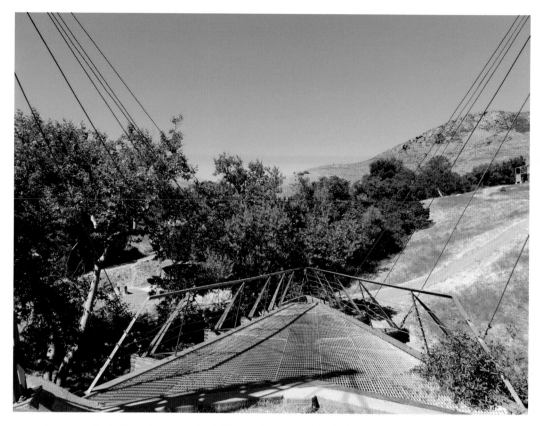

Looking up the hill from the suspension bridge structure. Part of the Stick House is visible in the distance.

Though many of the buildings are severely dilapidated, each is still quite solid. Every structure in the canyon, from the Dr. Seuss-esque Underground House (constructed in 1982) to the gargantuan concrete sundial (1971), exists in some state of decay. Crumbling walls, broken windows, and rusting appurtenances abound, all laid bare to the merciless elements. Since the last full-time student caretakers moved out of the canyon nearly two decades ago, local vandals have had free reign.

Originally purely experimental, each construct was state-of-the-art when first conceived. Poly Canyon's existence is testament to mankind's willingness to test the boundaries of established engineering and architectural science. Fittingly, the "experimental outdoor laboratory" has met the same fate as so many other wonders of engineering throughout time: left to slowly rot as humanity's quest for greater things, unending and unstoppable, marches steadily onward.

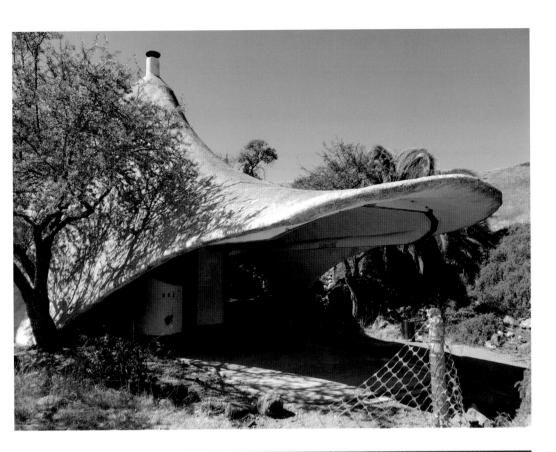

Above: The whimsical Shell House owes its name to its decidedly organic appearance.

Right: The stained-glass skylight at the pinnacle of Shell House's concrete peak.

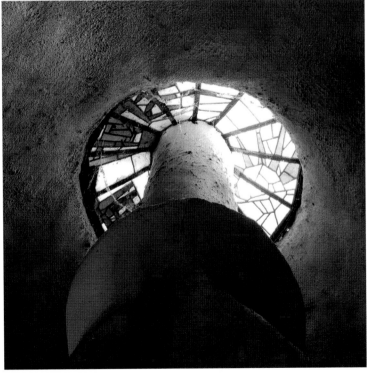

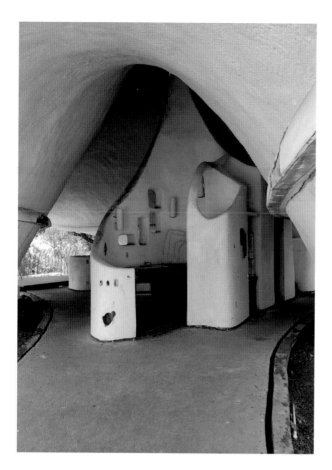

Left: The interior of Shell House. When first constructed, the gaps between the roof's edge and concrete floor were bridged with windows.

Below left: The concrete ladder to the central loft in Shell House. When it was first built, the alcove behind these stairs featured a waterfall.

Below right: This mural on the bathroom wall depicts the construction of Shell House. Note the central column with guywires suspended between it and the ground. Concrete would have been sprayed over the latticework of wire to create the distinctive roof. Once dry, the central support was removed.

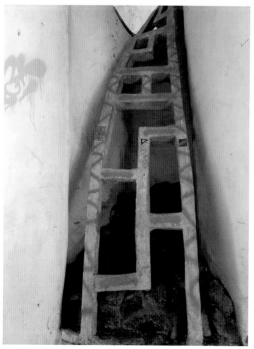

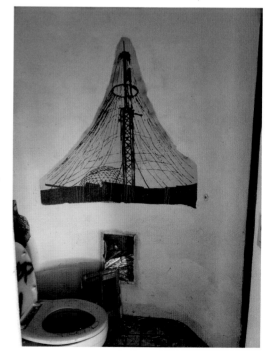

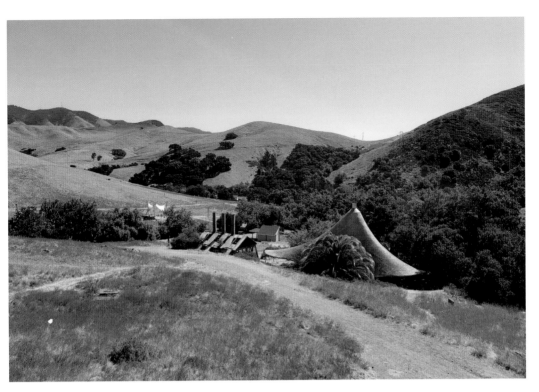

Looking down the hill towards Shell House, with other structures prominently visible.

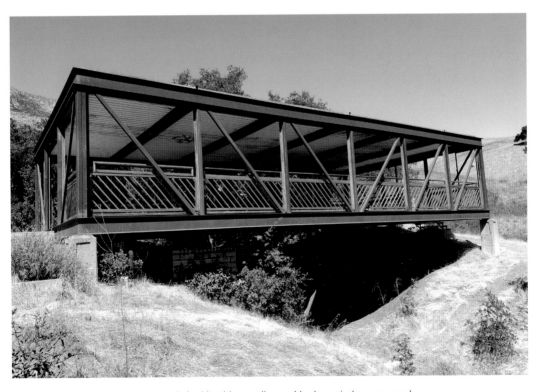

The Bridge House has recently had its side paneling and broken windows removed.

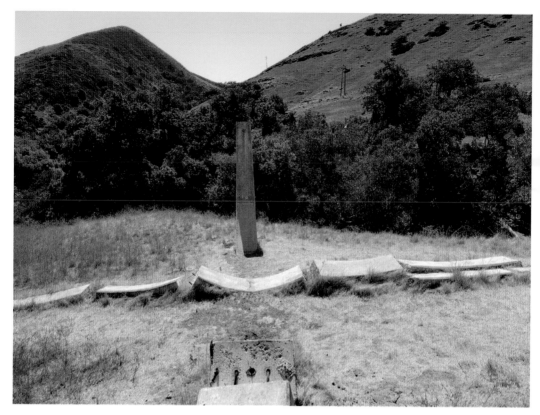

The old concrete sundial has almost completely collapsed, owing to several design flaws. It has since been replaced with another.

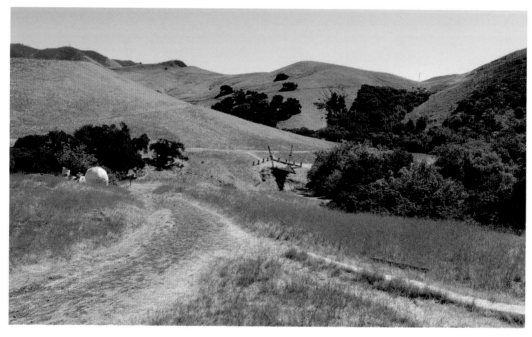

Looking down the hill towards Underground House and Suspension Bridge.

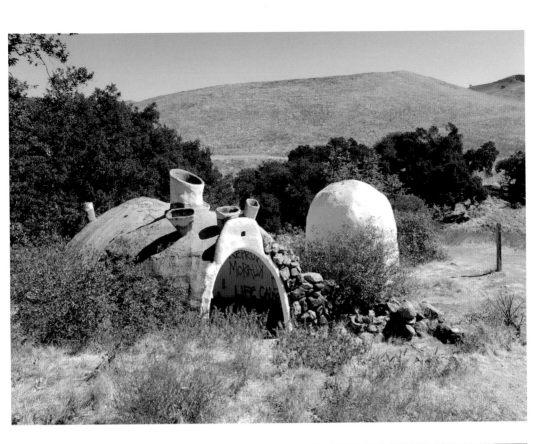

Above: Underground House is one of the more fantastical buildings at Poly Canyon, yet it is also one of the few which was once habitable.

Right: The bathroom at Underground House displays architectural styling in keeping with the house's overall design.

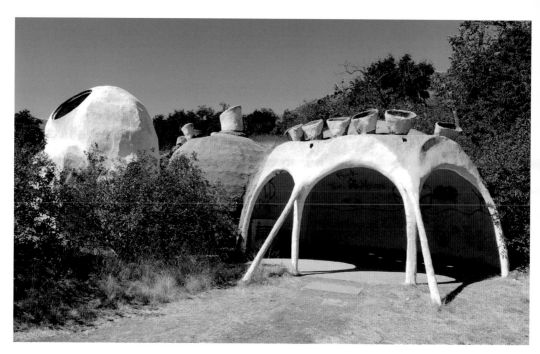

The front of Underground House.

The interior space of Underground House.

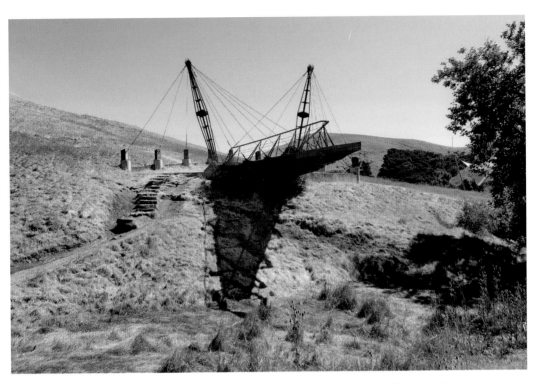

The imposing Suspension Bridge structure has stood strong for decades. It is still capable of supporting a group of people on its observation deck.

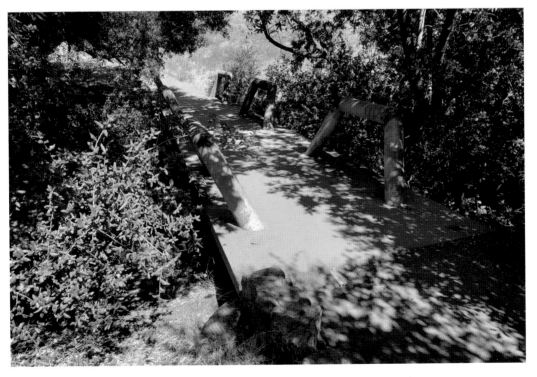

The whimsical, but functional bridge providing access to the architecture graveyard.

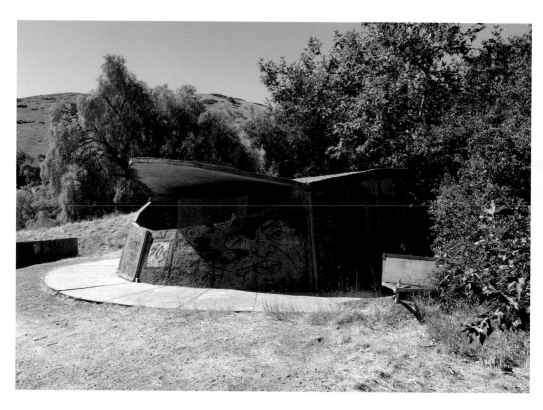

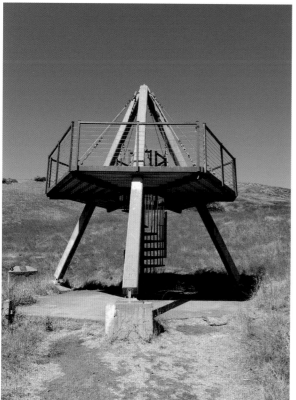

Above: The bathrooms are in a state of disrepair, but are nonetheless an interesting design exercise.

Left: One of the more recent structures to be added to the canyon, this observation deck affords an excellent view of the architecture graveyard and surrounding scenery.

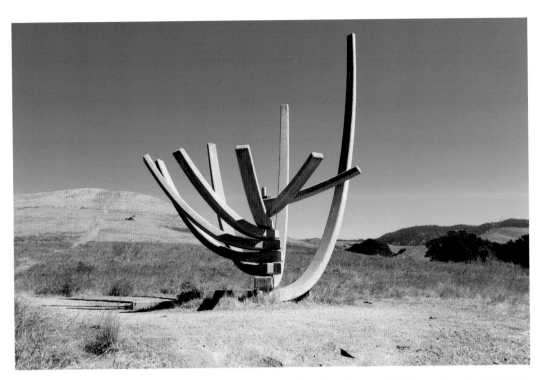

This colossal sundial stands prominently on a ridge overlooking the entrance to Poly Canyon. It was built to replace the older structure up the hill following its collapse. The updated design is much sturdier, but still functional.

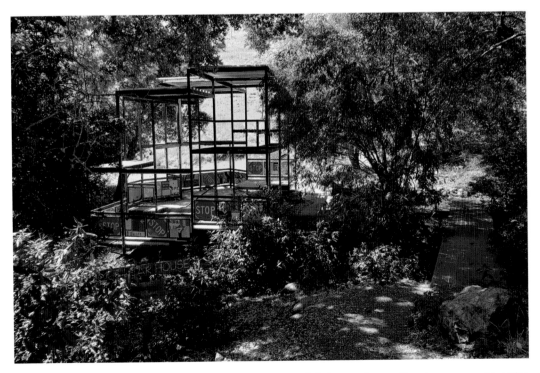

The Modular House was the last student occupied home in Poly Canyon. As recently as ten years ago this edifice still had walls, stairs, and fixtures.

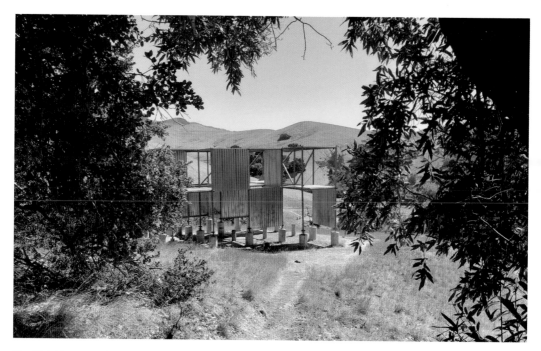

The Stick House was, in fact, never intended as a livable structure. Instead, this unique edifice was intended to test several design theories which might eventually find a practical application in architectural science.

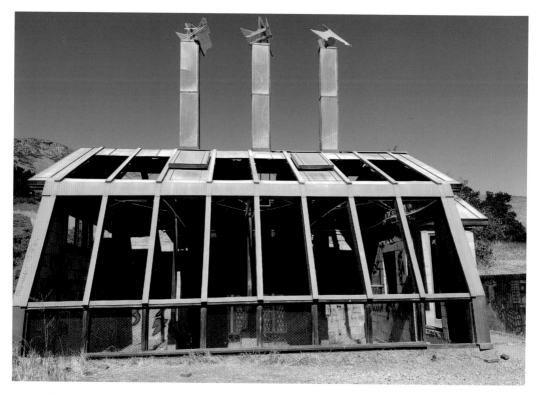

The greenhouse used an innovative ventilation system to allow air to flow through the structure. The stacks still protruding from its roof are remnants of this ingenious design.

4

RACE TO THE BOTTOM
Rinconada Mine

L ocated in the hills of eastern San Luis Obispo County, near the tiny enclave of Pozo on the edge of Los Padres National Forest, the former Rinconada Mercury Mine is unique among California's abandonments in that more remains of the physical site than the history behind it. California in general, and San Luis Obispo County in particular, once led the nation in mercury production. As a result, innumerable abandoned mines are scattered throughout the county, most dynamited, closed, or cordoned off with "bat bars." The majority are a continuing source of pollution for nearby settlements, with a few noteworthy examples (omitted from this work in the interest of public safety) being so heavily contaminated that they've earned a place on the EPA's infamous National Priorities List, more commonly known as the Superfund program.

Used in a diverse array of industries ranging from medicine to industrial chlorine gas production, mercury is one of the rarest naturally occurring elements in Earth's crust. The distinctive, highly toxic liquid metal is most commonly found in cinnabar, from which it is harvested by pulverizing the ore in a vertical crusher before it is fed into a rotating metal cylinder called a retort and heated. The resultant vapor is then condensed into pure mercury. The remaining ore and calcite dust was usually dumped in open-air tailing piles, which over time leached into the surrounding soil and was eventually washed into nearby waterways. Lax environmental standards and a general lack of accountability made cleanup efforts at many mercury production sites unusually difficult; even today, exploring an abandoned mercury mine carries risks well beyond those normally encountered by urban explorers.

The Rinconada mine was in operation from roughly 1872 through the mid-1960s, with production peaking during the first and second World Wars, when the metal's

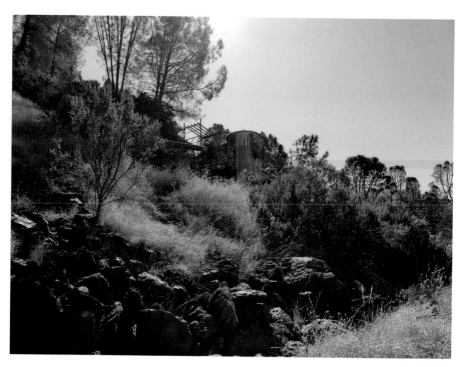

As visitors ascend the trail from the parking lot, the processing machinery gradually comes into view.

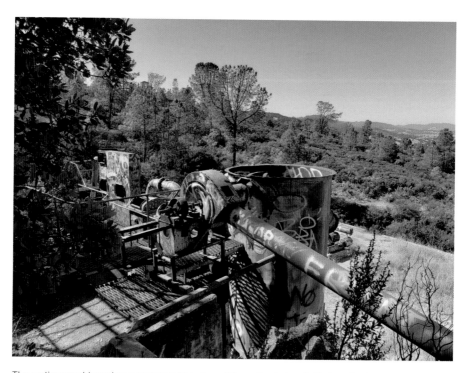

The rusting machinery has a commanding view of the valley below it. Eastern San Luis Obispo County is rugged and sparsely populated. Despite the nearby hiking trail's popularity during the spring and summer months, it is rare to encounter another human being at the mine site.

usefulness in the production of munitions made it a valuable commodity. Even so, the mine was always considered a low-volume producer compared to similar, much larger operations throughout the state. Quicksilver Resources of California, published in 1918, described the operation:

> The property was located in 1872 and in 1876 was equipped with a furnace of the old sheet-iron type, with 5 sheet-iron condensors. The designed attempted to keep the mercury vapor separated from the fuel smoke, but the only definite result achieved appears to have been the salivation of the furnace employees. It is said that little if any quicksilver was recovered, and the plant was abandoned in 1883. In 1897, two benches of 10-pipe retorts were put up; some rich ore treated and a small production made, but no definite figures of which are now obtainable. The upper tunnel, said to be 75' long, is now caved and inaccessible. Two intermediate adits were driven 40' and 25' respectively, and there is a lower adit 400' long as well as several shorter ones and open cuts.

Though the old Rinconada site was cleaned up in the early 2000s and is now part of a network of hiking trails, it is still riddled with more conventional hazards. The rusting remains of the crushing apparatus, roasting machinery, and various other devices are scattered about a flat area of land carved out of the adjacent hillside. This equipment is still structurally sound more than fifty years after it last saw service, and local artists and hooligans alike have made a canvas of the larger structures, painting them a variety of interesting colors interspersed with a few museum-worthy pieces.

Further up the hillside, a massive rent in the Earth opens into a yawning chasm almost fifty feet deep. The ground around the edges is highly unstable; just getting close should be considered extremely dangerous. The bottom of this fissure is accessed via some moderate climbing and descending a very flimsy steel ladder. Again, doing so is highly discommended for obvious reasons. From the floor of the pit, several tunnels stretch outwards in all directions, reaching deep into the bedrock. Nearly one-and-a-half miles of horizontal mineshafts are buried beneath the surrounding hills, rendered inaccessible by rows of thick steel bars placed across all remaining surface entrances. Local stories of teens disappearing into the toxic labyrinth beyond are purely fictional, albeit valid in their cautionary nature.

Today the myriad trails crisscrossing the oak covered hills surrounding the former mining site are popular with mountain bikers, hikers, and explorers just looking for something different. The official trailhead heads southeast from the parking area, away from the mine. A rough trail can be made out on the opposite side of the parking

lot by the astute observer, pushing west through the brush before curving south up a steep hill to the mine. The wild, unpopulated eastern edge of SLO County starkly contrasts the upscale coastal regions; the view from the former mine site provides a spectacular vista across the unspoiled valley below it. Even without the fascinating ruins nearby, this alone makes the hike well worth the effort. This is exactly as it should be: mankind›s toxic legacy slowly being reclaimed by the wilderness it once dared to intrude upon.

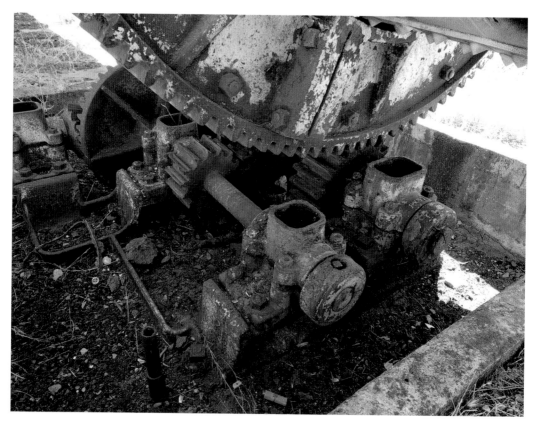

Everything rusts here.

OPPOSITE PAGE:

Above: It isn't easy to discern the function of some pieces of equipment here.

Below: The remaining machinery at Rinconada Mine is truly a sight to behold.

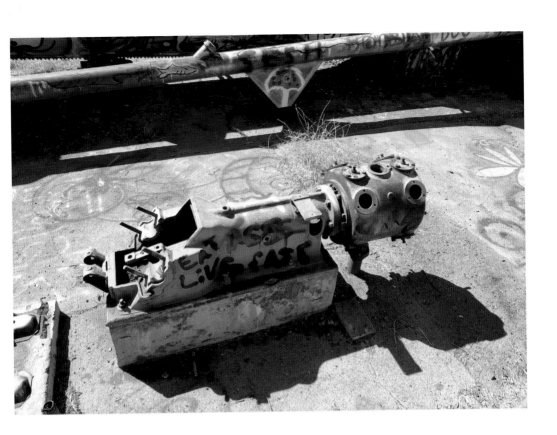

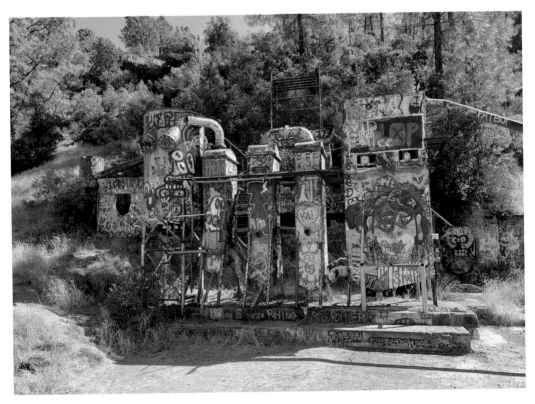

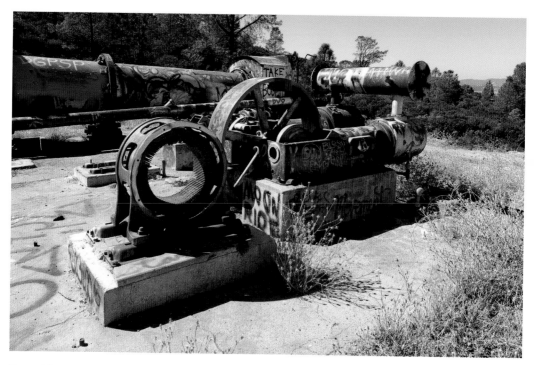

Some of the ore processing machinery, including what appears to be a steam driven dynamo in the foreground. The large metal cylinder in the background would have been filled with ore and heated as it slowly rotated, vaporizing the liquid mercury trapped within the raw cinnabar.

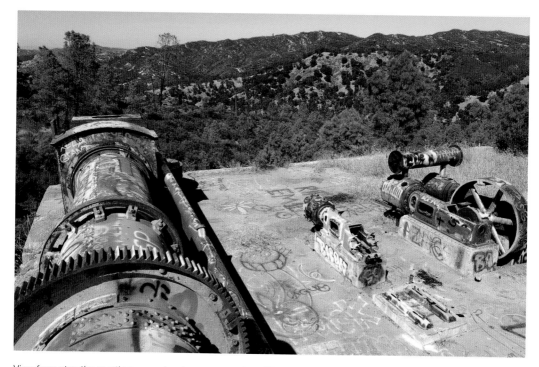

View from atop the roasting apparatus, known as a retort. The mercury vapor was collected after roasting and condensed into its liquid state for transport.

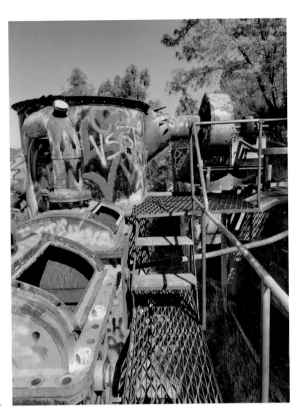

A closer look at the upper level of the processing machinery. Presumably, this large construct was used to crush the raw cinnabar ore prior to roasting. However, this is only speculation on the author's part.

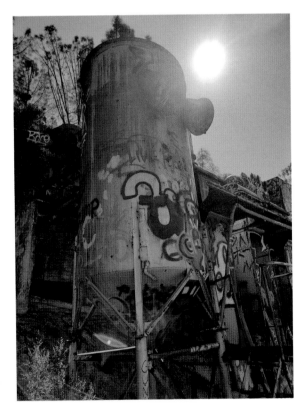

The graffiti at this site changes from week to week. In the past it has included some incredible works of art alongside the more common gibberish.

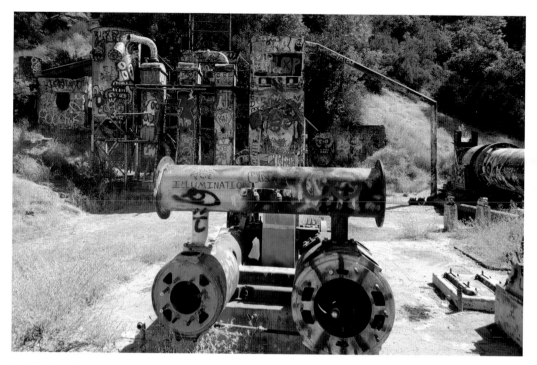

Another view of the processing equipment.

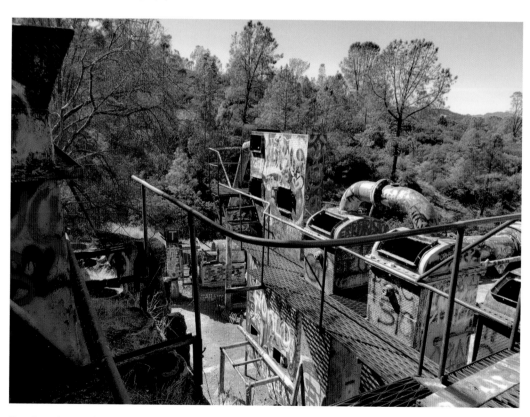

View from the top of the catwalk, looking down. The mine itself is further up the hill behind this assembly.

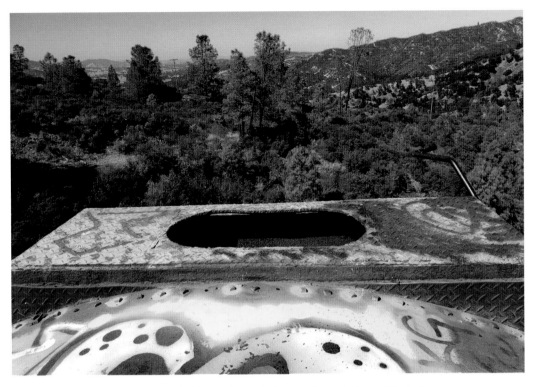

The view from atop the retort, looking west towards the small industrial town of Santa Margarita.

Above left: Discarded shell casings are not an uncommon site at remote locations such as this, as locals hoping to avoid shooting range fees sometimes sneak out to uninhabited areas instead. Finding unspent ammunition is decidedly less common.

Above right: The narrow staircase leading from the upper catwalk to the ground. Despite the rust, the mine equipment is remarkably sturdy for having been abandoned eight decades ago.

5

UNCLE SAM CALLS
Fort Ord

S ince it's bloody birth as a sovereign nation, the United States of America has
been embroiled in military conflict and war on a frequent basis. Expanding
aggressively across the continent throughout the nineteenth and early twen-
tieth centuries while fighting a string of wars both at home and abroad, Uncle Sam's
military might has rarely sat idle. Though we won't dwell on the abstract morality or
historical specifics of those conflicts between these pages, the comings and goings
of the United States armed forces have left a smattering of abandoned bases, supply
depots, shipyards, defensive structures, vehicles, and heavy support equipment
in California. From the scorched desert sands of Boron to the radioactive ruins of
Hunter's Point Shipyard in San Francisco, decaying military property can be found
in every corner of California.

Fittingly, one of the best-known of these empty bases can be found in California's
old territorial capital of Monterey. Founded in the late eighteenth century, the strategic
and economic importance of Monterey's position on the southern end of Monterey
Bay was well recognized by each nation whose flag has flown over its presidio. As far
back as the pre-colonial period, native Costanoans made their home on the bay, taking
advantage of the abundant fishing and natural resources along the Monterey Peninsula.
When Spanish missionaries raised the stone walls of Mission San Carlos Borromeo de
Carmelo, they likewise did not select the location arbitrarily. On the day of California's
annexation by the U.S., Old Glory was first raised over the territory at Monterey's Custom
House as a flotilla of heavily armed American frigates rode at anchor in the harbor.

By 1917, Monterey was a booming fishing and commercial port, the city's eco-
nomic power boosted further by the explosive growth of agricultural production in

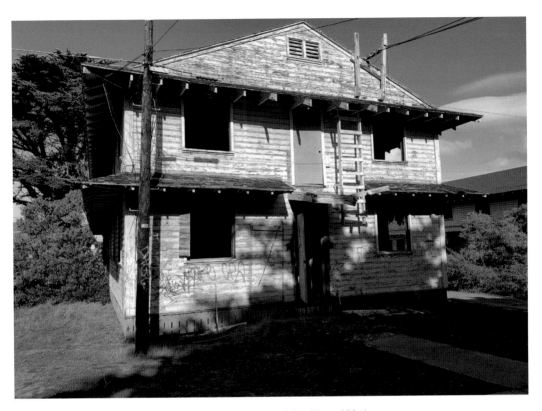

Hulking, empty barracks are a common sight around Seaside and Marina.

nearby communities such as Salinas and Soledad. Ahead of its entry into the Great War, the U.S. Department of War decided to establish an artillery training range on the bay. The newly established Gigling Field Artillery Range would be completed too late to play a part in that particular war effort, but the Army would continue to expand its presence in the area despite the general demobilization of American military assets during the interwar period as the nation adopted a more isolationist style of foreign policy. In 1933, the artillery training field was rechristened Camp Ord (named for Union Army Major General Edward Otho Cresap Ord).

During the twenties and thirties, the camp continued to serve in its original capacity as an artillery training post, while also becoming home to a mounted cavalry training division prior to the mechanization of the Army›s mobile combat units. By 1940, it had become apparent to the American government that the conflict that was raging across Europe might not remain limited to that continent. Under the watchful eye of General "Vinegar Joe" Stilwell, the original camp was expanded to 20,000 acres. The reactivated 7th Infantry Division was permanently stationed at this newly

minted Fort Ord. Rows upon rows of barracks, officer housing, support buildings, and recreation halls were constructed by the skilled hands of German prisoners of war. The cities of Seaside and Marina sprang up on either side of the installation in response to the increased demand for goods, services, and off-base housing. By the time Japan mounted its infamous attack on Pearl Harbor, Fort Ord had grown from a backwater gunnery range to an important cog in America›s military machine.

Despite the importance of the base in training new recruits and defending the West Coast from (as was viewed at the time) the very real threat of invasion by Imperial Japanese forces, Fort Ord quickly became known as a desirable post. Even today it isn't difficult to see why; the California central coast was and is renowned for its mild climate and relaxed pace of life. Many of the large communal housing units were located within sight of beaches, the shimmering waters of the Pacific providing a welcome recreational opportunity to war-weary troops lucky enough to be stationed there. At its peak, the base also boasted two golf courses, two theaters, a swimming pool, a bowling alley and eleven churches; many of these survive today, though some have seemingly little time left. In the late fifties, the world-famous Laguna Seca Raceway opened nearby on land previously belonging to the Fort.

With the end of World War II and the fall of the Iron Curtain across Eastern Europe, Fort Ord entered the next chapter of its operational life. The installation's mission focus shifted from maintaining a defensive military presence back to training the next generation of Uncle Sam's finest. Between 1952 and 1954, the base's first (intentionally) permanent buildings were erected. For the next three decades, nearly two million recruits, among them this author's father and grandfather, would pass through the Fort's gates to undergo their basic training before heading off to the battlefields of Korea and Vietnam. The base was the first in the nation to be fully racially integrated. In 1970, President Richard Nixon closed the base to the public following nationwide protests in the wake of his administration's military intervention in Cambodia. That year, a march of over 3,000 protesters was turned away from the base at gunpoint.

Ultimately, neither communist subterfuge nor civil unrest would be responsible for the closure of the base; it would be all-American capitalism that drove the final nail into Fort Ord's coffin. In 1989, the Base Realignment and Closure Act was signed. Two years later, in the face of dramatic increases in the value of land in the area, the BRAC determined that continuing operations at Fort Ord would be more costly than it was worth. Like several other now-abandoned military installations across California, Fort Ord shut down for good in 1994. Its resident infantry unit was deactivated after a final engagement which ironically took place on American soil, pacifying civil upheaval during the 1992 LA Riots.

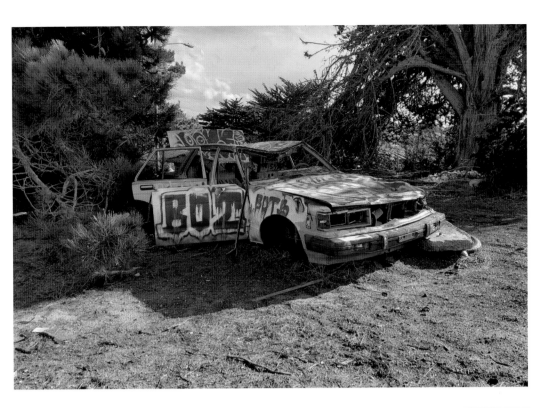

Above: A relatively rare Datsun Maxima diesel is slowly returning to the Earth outside one of the officers' quarters. Its LD28 engine's crankshaft is a sought-after component for racing Datsuns; perplexingly, this one appears to have become a paintball target.

Right: Fort Ord was considered a desirable posting due to its proximity to the coast. Ironically, this ideal location would play a part in the base's closure as the land beneath it skyrocketed in value.

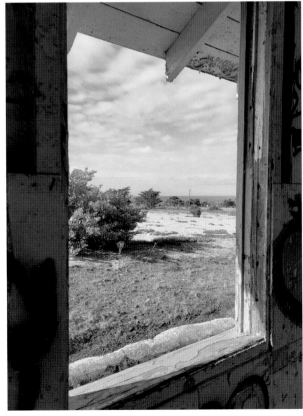

Today, much of the former base has been overtaken by the CSU Monterey campus, with some of the more robust housing units being converted into student dorms. Other parts of the base have been far less fortunate; much of the scenic enclave of Seaside is littered with blocks of hulking, empty dormitory buildings interspersed with smaller officer's quarters and auxiliary buildings. Some noteworthy buildings, such as the sprawling indoor swimming pool and stockade complex, have been secured for reuse. Others have slowly fallen victim to redevelopment as the nearby cities and State University expand outwards. The majority, though, exist in a tenuous state of dilapidation, the moist, salty air inexorably eroding the wooden bones of the fort's few remaining structures.

In April of 2012, President Barack Obama signed a presidential proclamation establishing Fort Ord National Monument. Managed by the BLM, the monument includes over 7,000 acres of undeveloped land covered by a crisscrossing network of hiking paths, bike paths, and spur trails. Additionally, since the base's closure, the locally run Fort Ord Reuse Authority has been active in the demolition of the remaining structures and general cleanup of the former installation. The rows of empty streets and abandoned barracks that are still standing currently exists on borrowed time, whether they ultimately succumb the developers' bulldozers or simple neglect a matter of grim speculation. It will not be long before the crumbling remains of this once-mighty military installation are little more than memory.

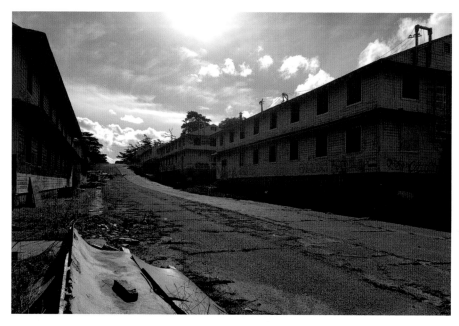

Rows upon rows of empty barracks litter several square miles of the City of Seaside. Beyond these are many more acres of support buildings.

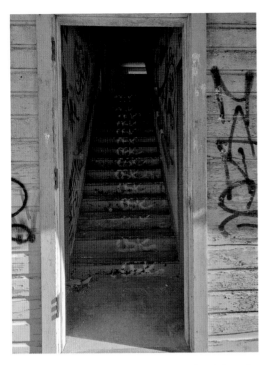
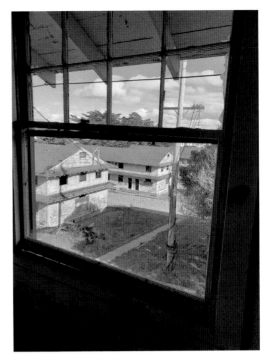

Above left: Stairs leading up into the darkened second story of a barracks building.

Above right: View from the upper story of one of the barracks buildings.

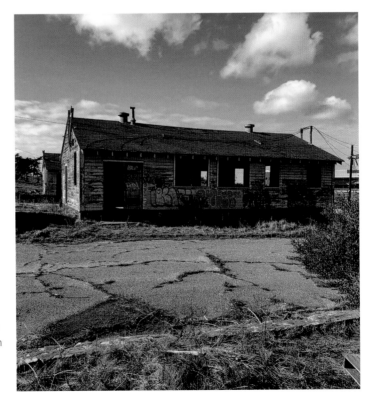

These smaller buildings lie at the head of each column of barracks. Their layout suggests that they were once officers' quarters.

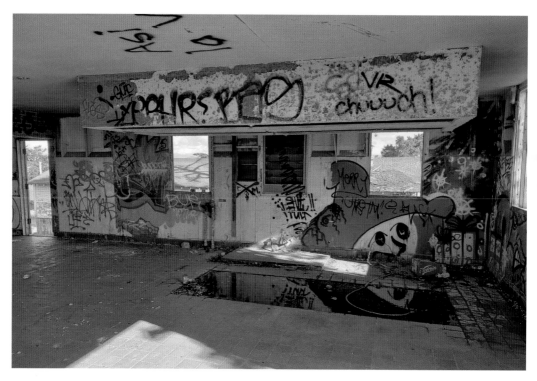

This building appears to have served as a kitchen and mess. Following its abandonment and the removal of the kitchen equipment, it is now only the latter.

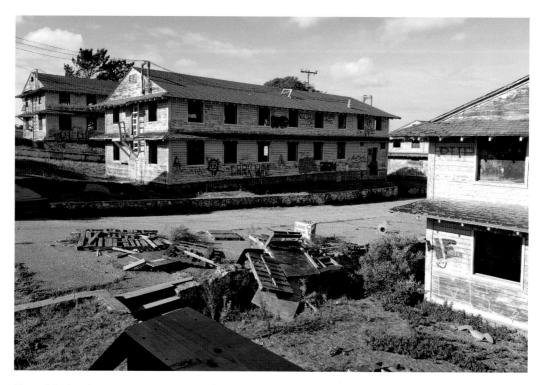

Many of the base's empty streets are littered with detritus, such as these discarded pallets.

This cast-off oven range lives on as a potent reminder of the power of self-acceptance.

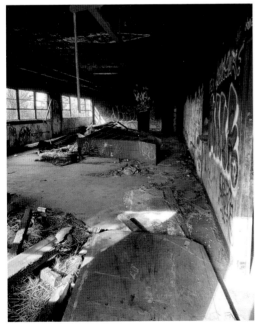

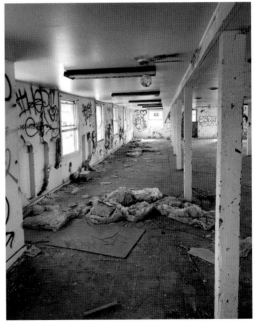

Above left: Some of the outbuildings are crispier than others. This warehouse was gutted by a fire at some point in the recent past.

Above right: The interiors of the buildings are slowly falling apart. Amazingly, most of them are structurally sound despite decades of exposure to corrosive coastal air.

Above left: Though mostly devoid of furnishings these days, occasionally bits of serviceable furniture can be found amongst the wreckage of the former military base.

Above right: Like many similar locations, guerilla artists are beginning to make use of Fort Ord's empty buildings as blank canvasses.

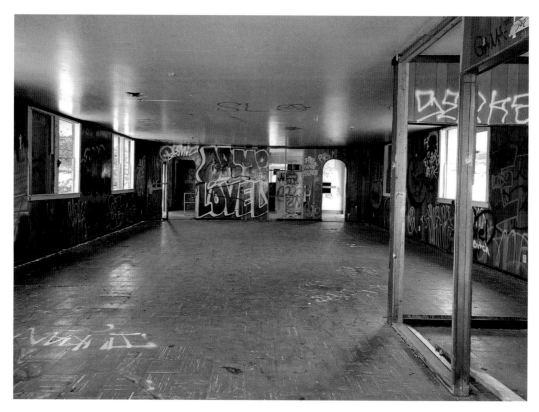

On a certain level, one can't help but admire the decor. The wood paneling is certainly a rustic touch.

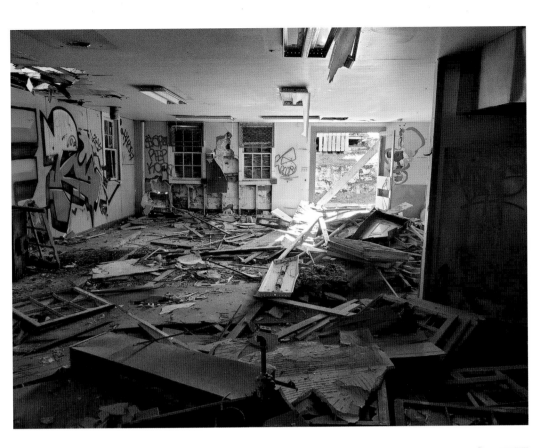

Above: Just looking at this image is enough to make your lungs itch. Respirators are an essential tool when exploring Fort Ord.

Right: Presumably this building functioned as a daycare center.

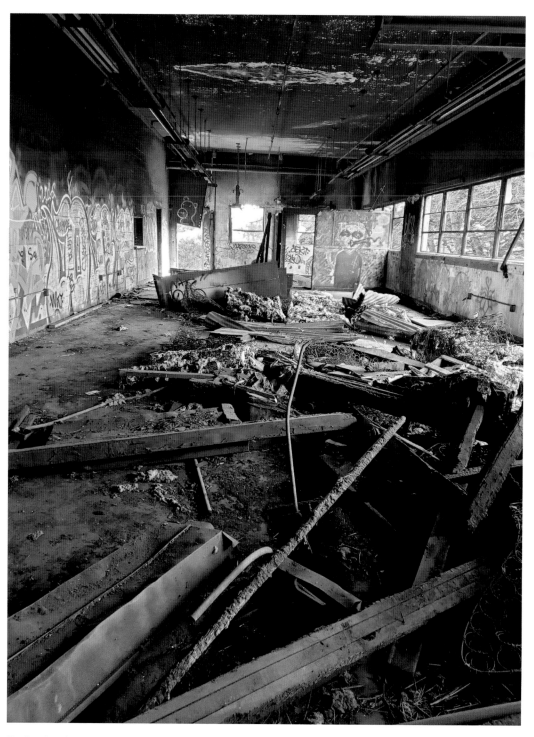

The interior of another burned-out building. Nature is slowly beginning to reclaim many of the empty buildings.

6

DEFENDING THE BAY
Devil's Slide Bunker and SF-51 Nike Missile Complex

S an Francisco Bay is one of California's most strategically important locations. A shipping hub eclipsed only by Los Angeles Harbor with considerable manufacturing capacity, the bay also hosts innumerable military facilities, both active and long abandoned. The naval yards at Mare Island and Hunter's Point, the Naval Air Stations at Alameda and Treasure Island, and the communications hub at Skaggs Island were just a few of the vitally important military assets located on the relatively safe waters of the San Francisco Bay and the surrounding tidelands. Drawing nearly limitless manpower from the heavily populated cities nearby, these installations were instrumental in the projection of U.S. military power abroad during World War II and into the Cold War era. Especially notable in the long and storied history of San Francisco's contribution to American war efforts, the heavy cruiser USS *Indianapolis* put into Mare Island for minor repairs in the spring of 1945 before proceeding to Hunter's Point to take on a top-secret cargo whose ultimate delivery would change the face of warfare forever: the first atom bomb.

Naturally, such a concentration of military might would be a tempting target for enemy activity. As such, the U.S. government channeled considerable funding and manpower towards ensuring that no hostile ships or aircraft would ever threaten the San Francisco Bay and its vital military assets or civilian population.

Though fortifications had been established at Fort Point and Alcatraz Island during the latter half of the nineteenth century, it would be several decades into the twentieth century before the United States Government took a long look at the defensive emplacements surrounding it's most vital West Coast strongpoint and find them wanting. Beginning in the 1930s, construction of huge coastal batteries and bunkers

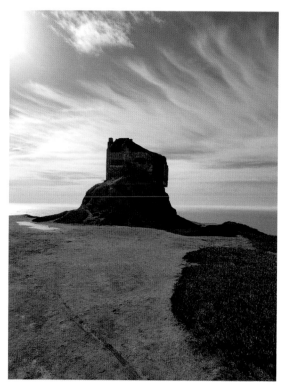

Left: The back side of the Devil's Slide Bunker, as seen from the nearby highway.

Below: The gun emplacements at Battery 244 were part of a network of artillery surrounding the bay. These extensive fortifications were constructed to ensure that any hostile vessel within range of their considerable firepower would quickly become a marine habitat.

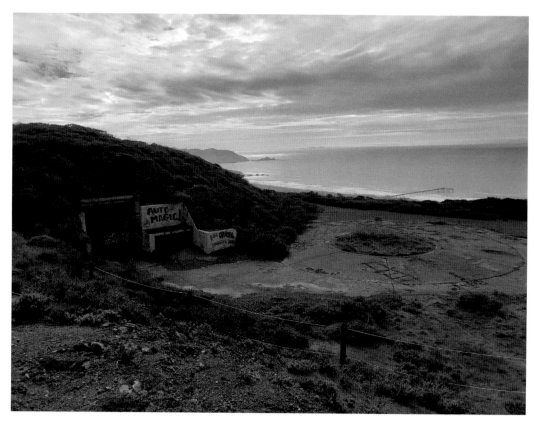

from Pacifica to the Marin Headlands was well underway by the time the first bomb fell on Pearl Harbor. Of particular strategic importance were those bunkers which were designed for the purpose of artillery triangulation. This process involved calculating the position of enemy ships spotted from one bastion according to their location offshore relative to several other spotters along the coast. Once accurate coordinates could be ascertained, nearby six-inch guns would be called into action to shoot a volley of explosive shells into the hostile vessel from the safety of the headlands.

Fortunately for the locals, fate eventually determined that these guns would never be fired in anger. With the end of the war and the advent of modern missile defense systems, the artillery placements and spotting bunkers were largely abandoned, left to slowly decay in the corrosive salt air. The impressive bunker at Devil's Slide is actually one of three surviving fire control bunkers just south of Pacifica. Left to the elements in 1949, the hilltop covering the former triangulation post was removed in the 70s for a construction project elsewhere. Incredibly, the completely exposed reinforced concrete edifice has managed to endure since then in spite of its highly precarious position. Accessing the site today is both dangerous and prohibited, though generations of local graffiti artists have nonetheless taken it upon themselves to decorate the decaying citadel.

Further up in the hills a few miles north of Devil's Slide, near the empty concrete gun pads and armored bunkers of Battery 244, the artillery defense system's replacement also lies in ruin. With the onset of the nuclear age, military defense in the Bay Area shifted its focus from defeating invasion by sea to counteracting the threat posed by long-range Soviet bombers. Cutting-edge Nike anti-aircraft missiles were quickly placed on launch pads at a total of eleven locations scattered around the Bay Area to form a protective screen against hostile air attack. Named for the Greek goddess of victory, these formidable weapons were capable of intercepting high-flying jets well before they were within striking distance of their targets. This system was not unique to the Bay area; Nike missiles would also be stationed around other key cities on the West Coast such as Seattle and Los Angeles, as well as being put to work guarding strategic assets all over the country.

The Nike complex placed on the headlands South of San Francisco, designated SF-51, was completed in 1956 and underwent several upgrades in 1958. SF-51 consisted of an administrative area (SF-51A), underground magazines and launchers (SF-51L) on Milagra Ridge, as well as an integrated fire control complex (SF-51C) at a higher elevation on nearby Sweeny Ridge. The latter site housed the radar systems which continually swept the skies for signs of hostile activity. If enemy aircraft were to be detected, intercepting missiles could be sent screaming into the sky within ten seconds, guided via radar from the fire control center towards their doomed targets. Though impressive by the standards of the early Cold War era, by

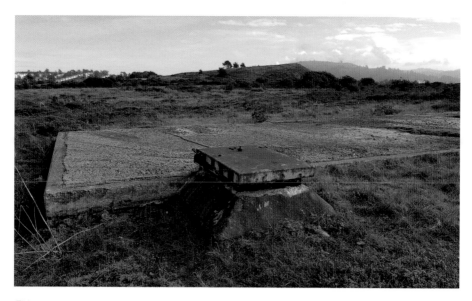

This concrete slab covers what once would have been retractable doors over an underground missile storage magazine. Several such magazines once housed Milagra's compliment of Nike missiles on retracting launchers.

the 1970s this system was quickly becoming obsolete. With the advent of modern intercontinental ballistic missiles, the Nike system became woefully inadequate as a defensive measure. SF-51 had its missiles, launchers and radar systems removed in 1974. For the next four-and-a-half decades, the concrete remnants stood as empty as the armored gun batteries they had replaced.

The rectangular pads upon which the missile launchers once stood, as well as the access hatches to their underground magazines, can still be seen from the trails now crisscrossing Milagra Ridge. Five miles away, a much more difficult hike to the top of Sweeny Ridge yields unfettered access to the remnants of the control complex. At some point in the very recent past, the remaining concrete and cinderblock fire control buildings were torn down; today the only remains of SF-51C are the concrete foundations of the former control center and the raised platforms which once supported the radar tracking equipment.

Both Milagra Ridge and Sweeny Ridge are now part of the Golden Gate National Recreation Area and are open to the public year-round. Unlike many of the military facilities left to rot on the shores of San Francisco Bay, the bunker at Devil›s Slide and the missile defense network that replaced it are not hidden away behind fences, nor have they been removed to make way for the ever-expanding cities they once protected. Instead, they maintain their silent vigil, de-fanged but ultimately enduring long after the enemies they stood sentinel against fell.

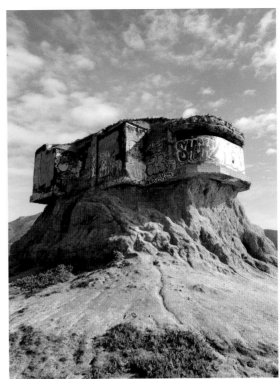

Right: The imposing concrete citadel perched atop the bluffs is visible to northbound travelers on Highway 1 from several miles away.

Below: The side profile of the exposed bunkerworks is reminiscent of the bridge of some colossal warship, plucked from the waves and placed atop this windswept bluff to stand watch over the surrounding shoreline.

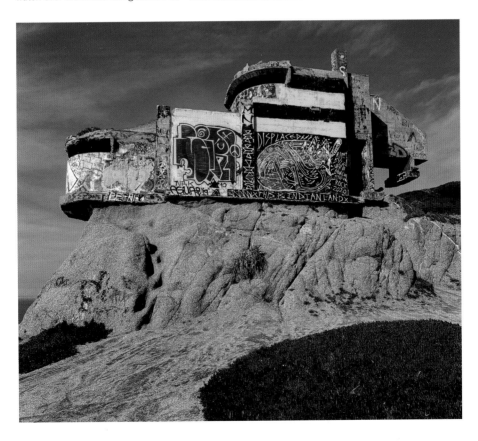

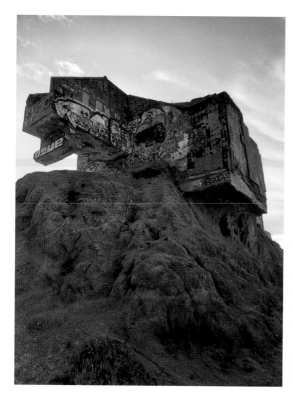

Left: Looking up at the rear of the bunker. The original entrances far above have been concreted shut. Access is now only possible by squeezing in through the viewports on the seaward side. Naturally, this is both a difficult and dangerous venture that is not recommended.

Below: The batteries atop Milagra Ridge have an excellent view by operational necessity.

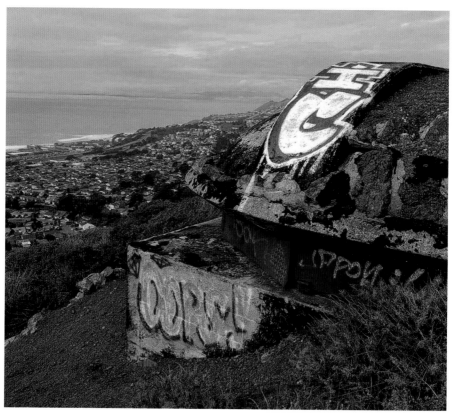

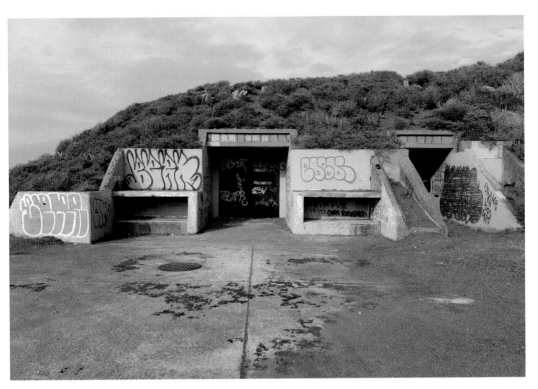

The armored doors of one of Battery 244s bunkers. Municipal authorities briefly made use of the empty passages within for records storage. This arrangement ended when vandals managed to break in and set those records ablaze.

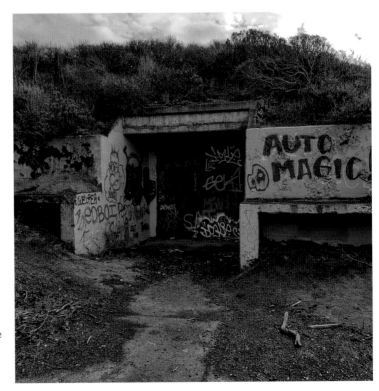

The back entrance of one of the bunkers atop Milagra Ridge. The sturdy steel doors provided modest protection from retaliatory fire, though naturally the safest place to be during such an event was still pretty much anywhere else.

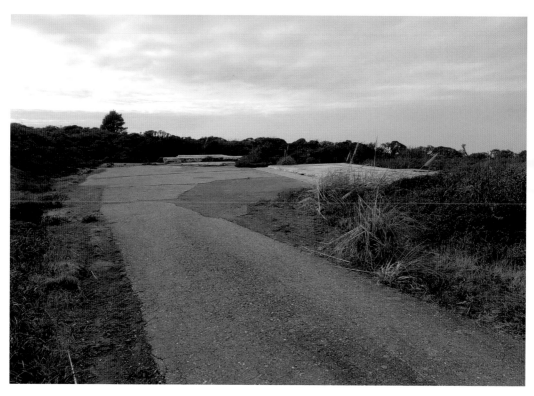

These concrete pads are all that is left of the SF-51 fire control center. The foundations once supported several cinderblock buildings, as well as an assortment of radar antennae and other vital equipment.

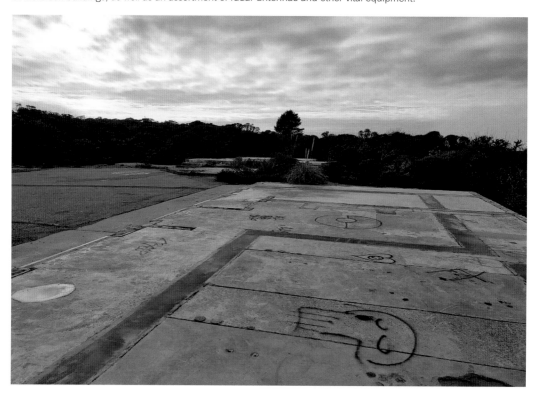

The stairs lead up to this circular platform which once held radar tracking equipment. This radar would have been vital for guiding the missiles from nearby Milagra Ridge to their airborne targets.

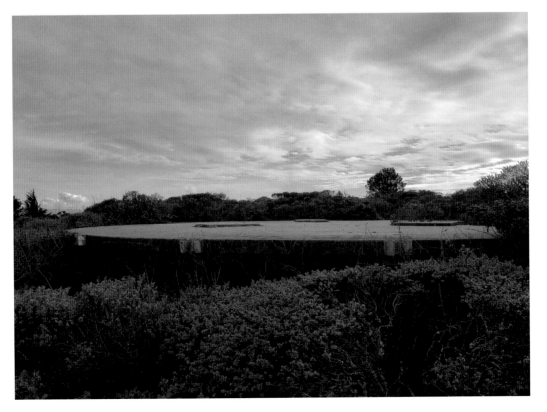

Left: The four-mile hike to the summit of Sweeny Ridge is unreasonably steep for the majority of its ascent. Bearing that in mind, this encouraging piece of graffiti near the summit required Herculean effort from its nameless creator.

Below: Looking downhill along the road leading to the old fire control center. On clear days, the unparalleled views of South San Francisco alone are worth the trek.

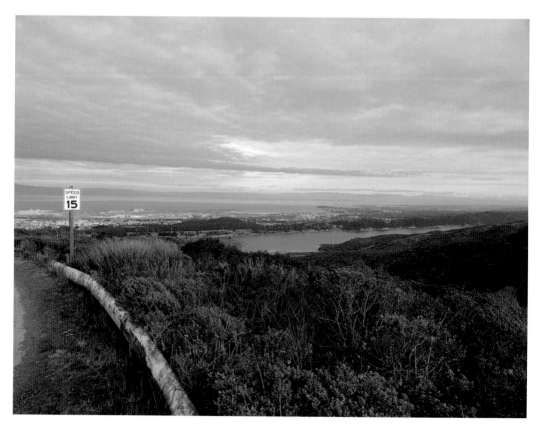

7

WHERE THE CLIFF MEETS THE SEA
Sutro Baths and Land's End

San Francisco has always exemplified California's spirit of exceptionalism and promise of opportunity. Beginning as a Spanish mission settlement the same year as that the Declaration of Independence was signed, the city saw its most explosive growth during and immediately after the famed California Gold Rush of 1849. By 1900, about a quarter of California's population resided within the rapidly expanding city. By the late nineteenth century, the city by the bay had become a major focal point of Californian arts and culture. Inevitably, wealthy businessmen and captains of industry were drawn to this beacon of metropolitan society on an otherwise untamed frontier; San Francisco's wealth and influence grew in pace with its population.

One of the most important men to call the city home during this critical point in its history was a German immigrant by the name of Adolph Sutro. Arriving in the gold fields from Baltimore in the early 1850s, Sutro soon made a name for himself as a businessman and entrepreneur. Having amassed considerable wealth for himself building drainage tunnels for the expansive gold mining operations in the Comstock Lode and investing heavily in San Francisco's valuable real estate, Sutro permanently settled in the city in the late 1870s. Though he would eventually become mayor of the city, arguably his most impressive mark on San Francisco's history was the sprawling entertainment complex he built on the shores beneath what would become known as Sutro Heights.

Construction of the Sutro Baths began in 1896, alongside Sutro's equally magnificent chateau, Cliff House. The sprawling public entertainment complex would include an amphitheater, museum, dressing rooms and an ice-skating rink. However, the public baths themselves were the complex's most spectacular feature. Six saltwater pools,

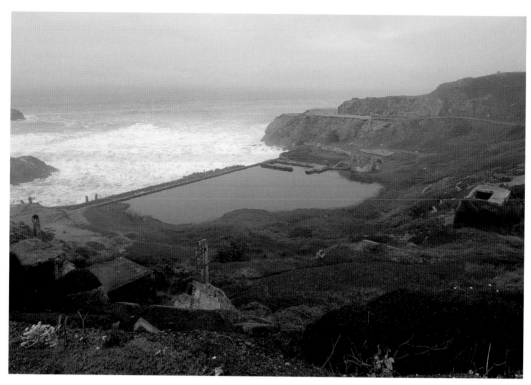

The remains of Sutro Baths, viewed from Cliff House.

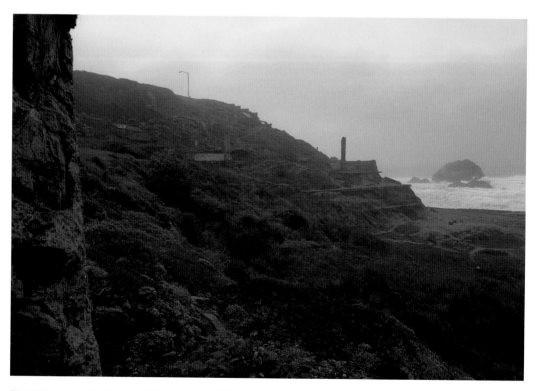

The cliffs surrounding the crumbling pools are still dotted with decaying walls of stone and concrete.

as well as one freshwater pool, boasted a combined capacity of 1.8-million gallons. The pool area included several slides, swinging rings and a springboard and was fed by the natural action of the ocean currents during high tide. During low tide, immensely powerful turbine pumps would be switched on to allow the water to be continually recycled without nature's assistance.

Two private railroads ferried passengers to and from the complex. The baths themselves had a capacity of 10,000 people, and frequently met that capacity during the height of their popularity. The baths were, however, never a profitable venture. As attendance declined over the decades, the astronomical cost of maintaining the facilities became impossible to justify. In the mid-1960s, the Sutro Baths closed for good, the land under them sold to a developer with the intent of erecting luxury condominiums in their place. Were it not for an act of arson in 1966, the story would have ended there. After mysteriously burning to the ground, the gutted remains of the once-glorious building were left to the elements, the developers choosing to take the insurance payout for the fire and leave town. In 1973 the former baths became part of the Golden Gate National Recreation Area.

Today the pools and various concrete shells are open to visitors, freely accessible via several trails from the Cliff House (now a restaurant), Land's End Visitor's Center and Land's End walking trail, which follows the path of one of the railroads that once ferried beachgoers and wayfarers to Sutro's awe-inspiring bath house. Following this trail up the hill to the north of the baths, on clear days explorers can catch a glimpse of what remains of the Mile Rock Lighthouse. Built on an offshore rock outcropping to safely guide shipping through the Golden Gate, the unique lighthouse was truncated and abandoned in the early 60s. However, there is a much closer, more accessible navigational aide just up the hill from the walking trail.

Most visitors to Land's End cast their gaze seaward, looking across the vastness of the Golden Gate towards the distant Marin Headlands and Point Bonita Lighthouse. Behind these sightseers, hidden on the hilltop beneath a dense copse of Monterey cypresses, a long-forgotten piece of Land's End's history sits empty. The Octagon House, in its day known as the Marine Exchange, was completed in 1927, the last of a succession of watch stations on the hill whose purpose was to spot incoming vessels and alert the customs authorities, drayage companies and stevedores on the Embarcadero that their various services would soon be needed. Originally consisting of a complex series of semaphore signals and relay stations, by the time the current Octagon House entered service telegraph wires had been run from the hilltop to the docks. The lower floor housed a garage, while the uppermost floor housed a powerful telescope and communication equipment. The lookouts and their families occupied the middle floor of the residence.

The need for a manned observatory at Land›s End would exist until direct, reliable radio communication between ships and onshore authorities became possible. During its service, the Octagon House played an additional role in that it also provided direct observation of all incoming and outgoing shipping. Unlike the various lifesaving stations and lighthouses scattered around the Golden Gate, during the era before electronic communication the Marine Exchange observation station had a fast, direct line of information exchange with the docks along the Embarcadero, from which the port›s innumerable tugs, taxis, and merchant vessels were primarily based. Many lives would be saved over the years by the vigilant lookouts who occupied the Exchange.

Following its decommissioning, the Octagon House was home to the wife of its last lookout until she was forced by old age to relinquish her occupancy in 2002. Afterwards the empty house slowly fell into disrepair. One external stairway either collapsed or has been removed, while another has been used to store various pieces of debris. All windows on the lower two floors have been boarded over to deter squatters and vandals. Encouragingly, the National Park Service has indicated its intent to restore the structure and open it to the public. Perhaps one day soon visitors to Land›s End will be able to ascend the stairs within the Exchange building and look out across the Pacific from the observation deck. Until then, the empty shell perched on a lonely hilltop remains a fascinating piece of the city›s rich history.

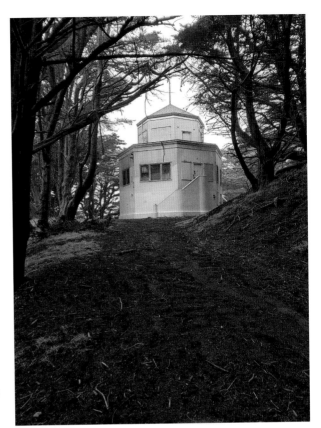

Right: The Land's End Merchant's Exchange watchtower is now all but obscured by the surrounding trees.

Below: The remains of the Sutro Baths betray markedly little of their original opulence.

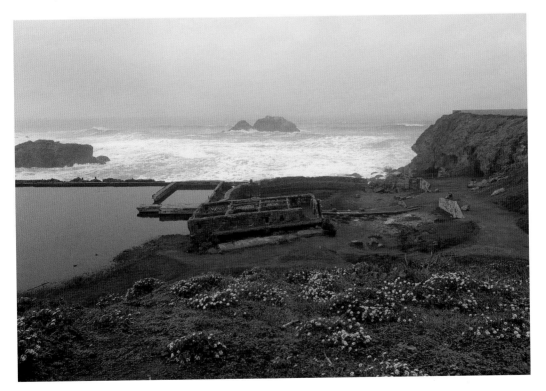

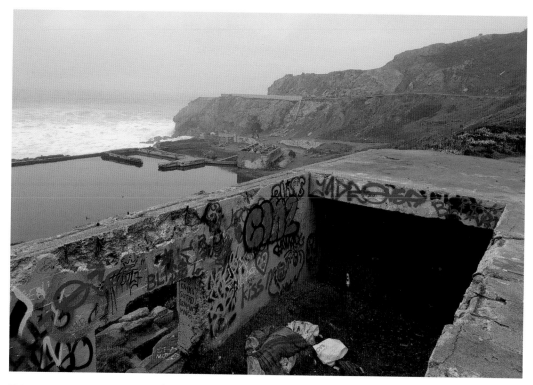

This concrete shell was home to a recently vacated homeless encampment. Its original purpose is anyone's guess.

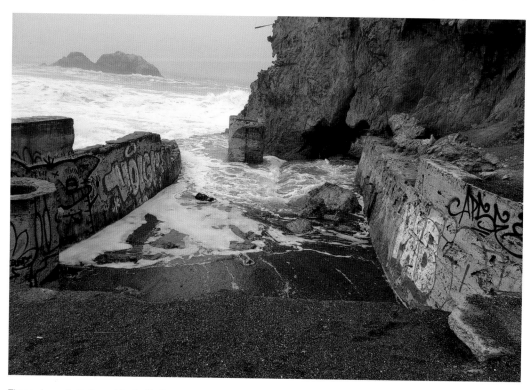

These channels likely contributed to the recirculation of the water in the gargantuan saltwater pools via tidal action.

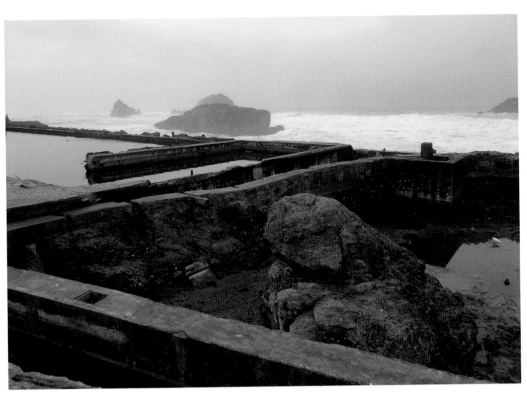

More views of the decaying baths. Though unimpressive today, these pools drew massive crowds during the early years of their operation. They are still attracting visitors in the form of tourists, urban explorers, and fishermen.

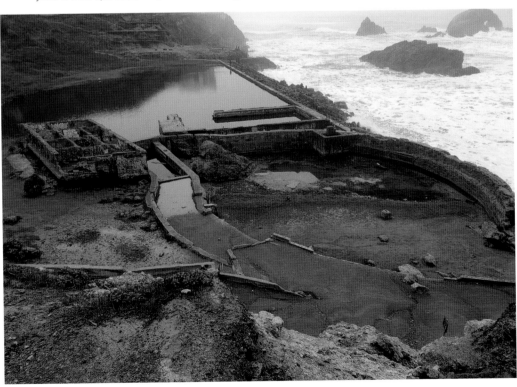

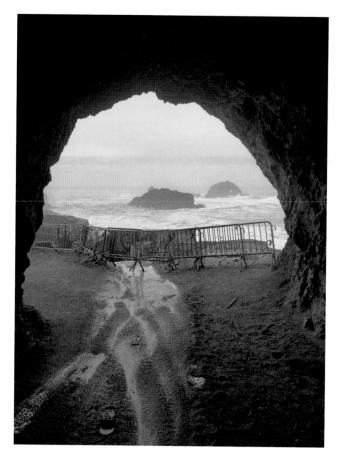

Left: Looking towards the baths from the sea cave at the base of the cliffs. This cave was likely once part of the network of pipes and tunnels which allowed the seawater in the baths to circulate.

Below left: The Land's End Octagon House is decidedly less popular with visitors than the baths on the shores below it. However, its uncelebrated role in San Francisco's history is arguably far more important.

Below right: Looking up the stairway towards the upper landing of the Octagon House. Note that the wooden stairs, although solid, are beginning to grow moss. This phenomenon is extremely common in the foggy, damp environs of Northern California's coastline.

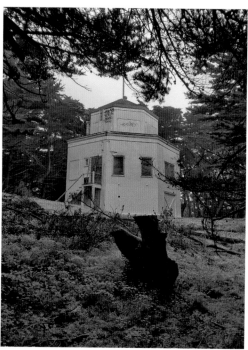

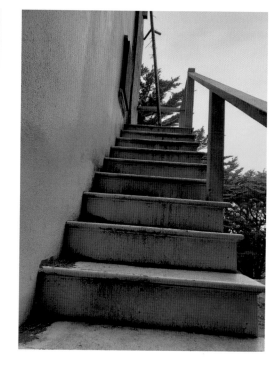

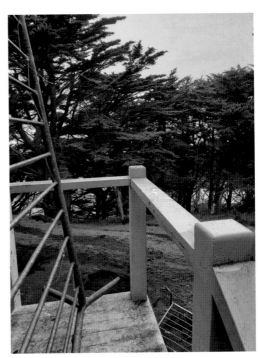

Though historically fascinating, the boarded-up shell of the Merchant's Exchange is fairly small and well secured against intrusion. One exterior stairway has been removed entirely.

Eagle-eyed visitors will quickly notice the truncated remains of the Mile Rocks Lighthouse not far from Land's End. Constructed on a dangerous outcropping of rocks not far from the Golden Gate, the powerful beacon once functioned in tandem with the Point Bonita lighthouse to the north, marking a safe channel for shipping between the two lights. In the 1960s, the light was discontinued, and the upper half of the tower removed shortly thereafter.

8

ILLUMINATING THE GOLDEN COAST
Punta Gorda Lighthouse

C alifornia's coastline stretches more than 700 miles from its southern border to its northernmost edge. Possessing two of the country's most vital commercial ports and innumerable industries reliant in some capacity on maritime trade, it is altogether unsurprising that Congress made funding for navigational aids along the golden coast a top priority following the massive influx of fortune seekers during the famed Gold Rush and subsequent admission of the state to the Union in 1850. The first lighthouse on the West Coast was lit on Alcatraz island in 1854, with several others soon following. California's age of economic ascendency had begun.

The most important locations for coastal beacons were meticulously selected by the newly formed Lighthouse Board, leaving smaller harbor towns and settlements to petition for funding for their own beacons as the need arose. One hazardous stretch of coastline in particular was in dire need of lighting, but it would take several disastrous shipwrecks before the ponderous bureaucracy of the distant federal government finally turned its attention to the golden state's remote Lost Coast.

One of the most distinctive features of northern California's coastline is Cape Mendocino. It is here that the coast curves sharply westward before bending back east again, creating a prominent bulge in an otherwise relatively straight stretch of shoreline. Ships hugging the coast as they make their way north must adjust their course westward to avoid slamming into the jagged cliffs that define this rugged, isolated seaboard. At either end of this 11-mile bulge are two distinct points. The northern point, Cape Mendocino, juts slightly further into the icy waters of the Pacific. It would receive its lighthouse in 1868. The diminutive cast iron structure was placed high up on the cliffs, its gargantuan first order Fresnel lens casting a brilliant light 25 miles seaward.

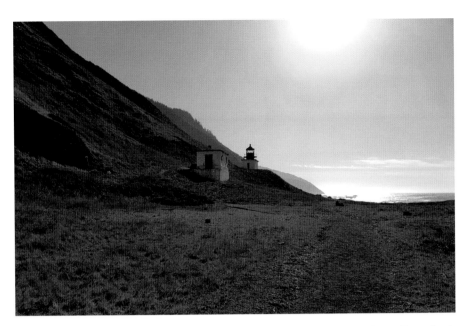

The lighthouse tower and oil storage/fog signal building are all that remains of the former Punta Gorda Light Station.

The southernmost point, Punta Gorda, remained dark for another thirty-nine years. In 1888, the Lighthouse Board made its first request for a beacon on Punta Gorda. This request would be repeated numerous times as ships continued to meet their end off the point over the years; the rusting remains of several can still be seen today. In 1907, one especially deadly incident finally convinced Congress to approve long-overdue funding for a lighthouse. The schooner *San Pedro*, steaming through heavy fog just west of the point, collided violently with a passenger liner, the *Columbia*. Eighty-seven lives were lost. At long last, Congress listened. Three years after the *San Pedro* disaster, the first loads of building material were landed on the coastline just north of the proposed construction site.

By 1911, the fog signal building and machinery were in place, along with a large barn, blacksmith shop, and three sizeable dwellings for the station crew. In June of that year, the gas engines and compressors for the fog signal first roared to life. Seven months later, on January 15 of 1912, Head Keeper Frederick Harrington lit the lamps for the first time. From the top of a 27-foot-tall reinforced concrete tower, the station's fourth order light cast its welcoming rays across the dark waters of the Lost Coast, flashing every fifteen seconds.

Life at the station was far from comfortable. Though not perched precariously on a wave-swept outcropping like Saint George's Reef Light to the north, nor quarantined

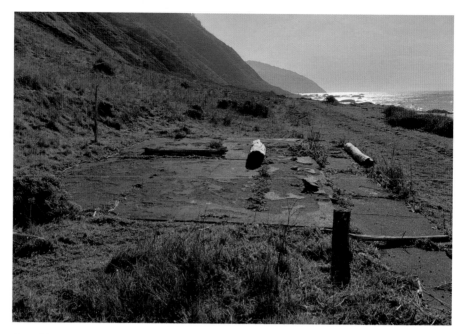

One of the remaining foundations. The station outbuildings were burned to the ground in the 1960s to discourage squatters.

on a lonely island far from shore like the Farallon Light Station off San Francisco Bay, Punta Gorda was nonetheless far removed from anything resembling civilization. The Lost Coast earned its name as a direct result of its sparse population and relative inaccessibility. The closest settlement to the light was the tiny town of Petrolia, eleven miles distant over rough terrain which was passable only during good weather and at low tide. Thus, the station's keepers and their families relied as much on their own ability to forage sustenance from the surrounding hills and ocean as they did on the infrequent resupply visits from the Lighthouse Board's support tenders. Unsurprisingly, this posting soon developed an unfavorable reputation among keepers serving on the west coast. Lightkeeping in the days before automation was never easy work at the best of times, requiring hard physical labor, skills, discipline, and self-reliance. The isolation at Punta Gorda only compounded this difficulty.

In the early 1930s, administration and upkeep of America›s navigational aids was transferred to the Coast Guard. A rough road was hewn southward from the Mattole River in 1935, allowing jeeps and tractors to ease the difficulties of day-to-day life at the lighthouse, albeit only during fair conditions. The fickle weather and punishing storms that routinely lash against the Lost Coast ensured that horses would never be completely obsolete. Electricity made its way to the station in the late thirties, but

the power lines often proved no less susceptible to local conditions than the road. Enormous generators were kept on standby and would regularly be called upon to keep the light burning through the worst gales.

Predictably, given the extreme difficulty of maintaining a lighthouse at Punta Gorda, it was abandoned as soon as navigation technology had advanced sufficiently to allow the Coast Guard to shutter the station. In 1951, a lighted buoy was anchored off the point and the buildings were all boarded up. The valuable lens was removed from the lantern room and the land was passed to the Bureau of Land Management. In the sixties, the empty structures were taken over by a countercultural group, whose removal and subsequent reoccupation several times over the years would be a continuing headache for local authorities. Realizing the liability that the crumbling light station posed, the BLM made the decision to burn the remaining wooden buildings to the ground in 1970.

Today all that remains of the station is the oil storage building and the lighthouse itself, though a few concrete foundations where less-resilient outbuildings once stood can also be seen nearby. Elephant seals bask on the shore during the warmer months, providing the only noise aside from the relentless pounding of the surf and howling winds. In stark contrast to the squat, square tower, the surrounding wilderness is pristine and untouched. The trail meandering from the mouth of the Mattole River to the empty lighthouse is a relatively moderate hike along the base of the steep cliffs and jagged shoreline. From May through September, the trail is popular with hikers, and there is plenty of dispersed camping and fishing nearby. Visitors hoping to reach the lighthouse should consult a tidal chart before heading out; there are two tidal pinch points along the trail that completely cut off access to the trailhead at high tide. Hikers should also be prepared to wade across Fourmile Creek if they lack the balance to negotiate the narrow log that serves as a rudimentary bridge. The reward for running this gauntlet is well worth the difficulty, as many backpackers would readily attest.

Though Punta Gorda Light went dark long ago, volunteers from across Humboldt County routinely make the journey to the remains of the station to shore up cracks in the aging concrete and make repairs to the vulnerable cast iron components. Their diligence is evident in the remarkable strength of the century-old staircase and lantern, both of which are still capable of supporting a large adult. Ultimately, the lonely tranquility and romantic appeal of this little lighthouse in the middle of nowhere ensures that someone will always be along to look after it, just as it once looked after those intrepid mariners who ply their trade on the unforgiving waters of the Lost Coast.

Left: The view of the sunlit Pacific from the tower's ground floor windows evokes a sense of calm, recalling the slower pace of life in an era long since passed. In reality, the wind howling through the building is absolutely deafening at nearly all times.

Below: These were likely fuel tanks for the air compressors which powered the fog signal. In the distant background is the first of two tidal choke points which must be traversed to reach the station.

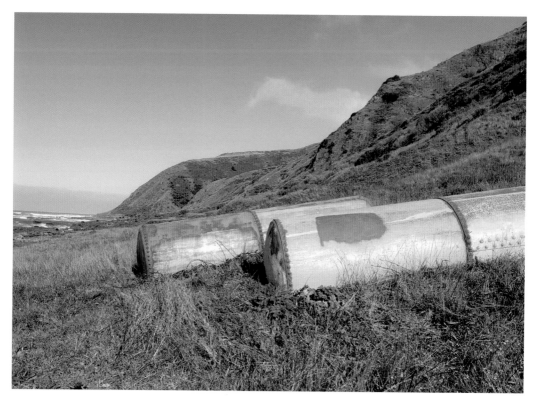

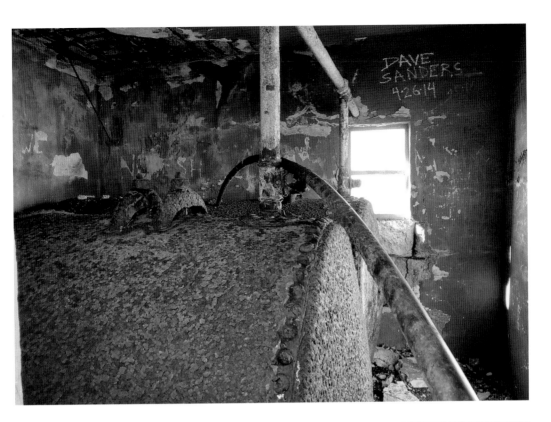

Above: The compressor tanks for the fog signal are slowly turning to dust in the salty atmosphere.

Right: The squat lighthouse on Punta Gorda is one of California's shortest. Its location on a low bluff positioned the focal plane of its light high enough to be visible miles out to sea while avoiding the dense fog banks which tend to form higher up.

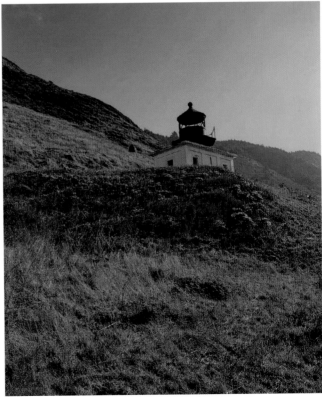

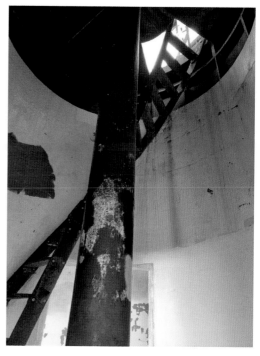

The central staircase winds upwards around the iron column which once held the clockwork weights for the lamp.
The weights would be wound up every few hours and the momentum of their descent would slowly turn the lens.

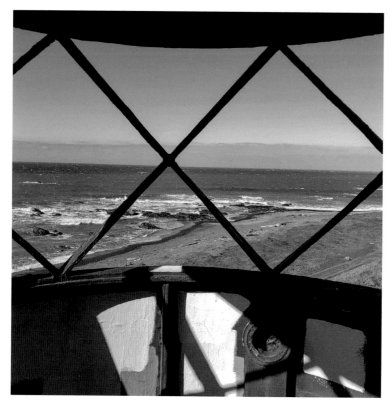

The view from the
tower's lantern
room is incredible
during fair weather.
Astoundingly, the
century-old wrought
iron is still in
remarkable condition.

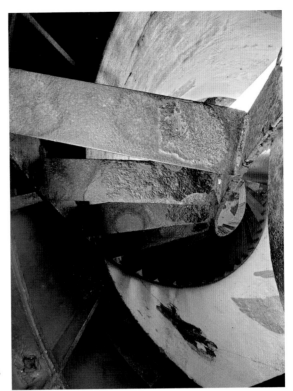

Right: Another view of the tower's staircase. Keepers had to ascend these stairs every two hours, carrying additional fuel for the lamps. During this time, the weights would also be rewound.

Below: The Punta Gorda lighthouse is a short, functional structure. The beacon's sturdy construction has endured the ravages of time commendably. However, it is beginning to show signs of wear.

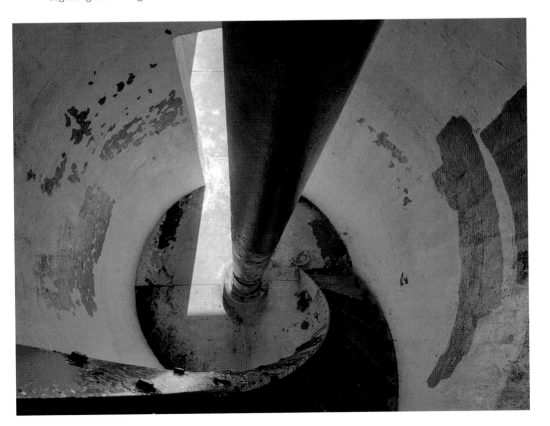

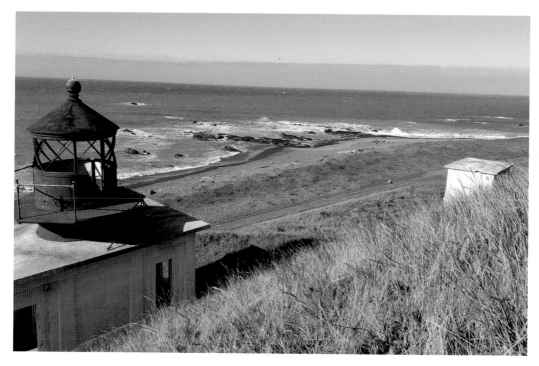

The bluffs behind the lighthouse rise to several hundred feet above sea level. In order to avoid the low-lying fog which frequently shrouds the area, the focal plane of the light was placed only about fifty feet above the water.

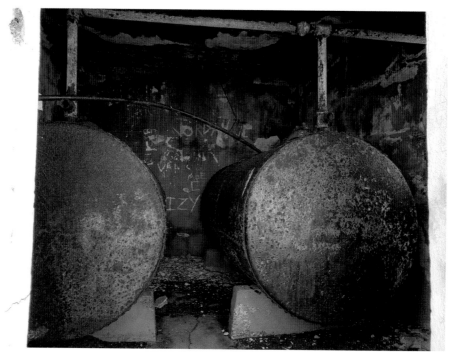

Another view of the pressure tanks in the fog signal building. The gargantuan size of the tanks allowed the foghorns to run around the clock.

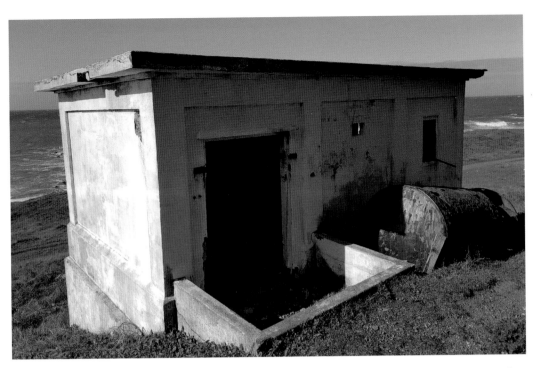

The masonry fog signal building is deteriorating much more rapidly than the tower. It is, however, still in excellent shape considering that it has endured six decades of neglect.

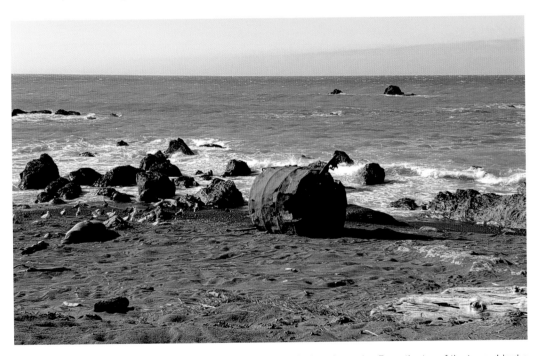

A colony of elephant seals has taken up residence on the beach nearby. From the top of the tower, I had a fantastic view of a fight between two massive males. The challenger was eventually driven off by the dominant bull. Note the rusted boiler lying on the beach amidst the animals, a remnant of one of the numerous shipwrecks which occurred off the point prior to the lighthouse's construction.

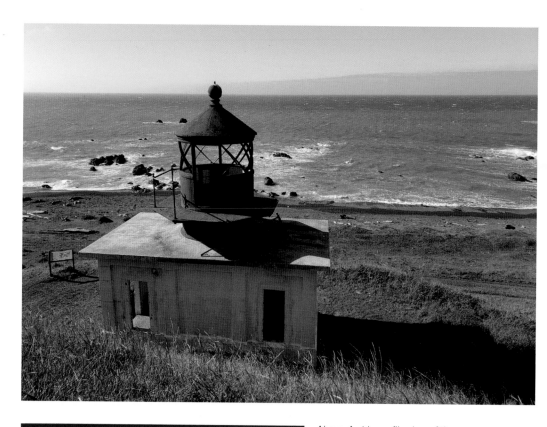

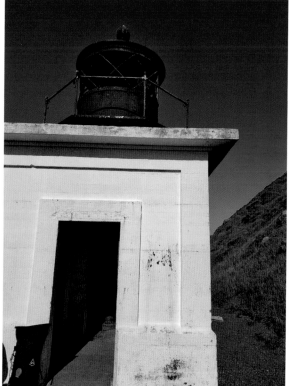

Above: A side profile view of the diminutive tower. The roaring waves of the Pacific Ocean are only a few hundred feet away.

Left: The view up towards the lantern from the bottom of the tower. Its diminutive stature is readily apparent from the tower's base.

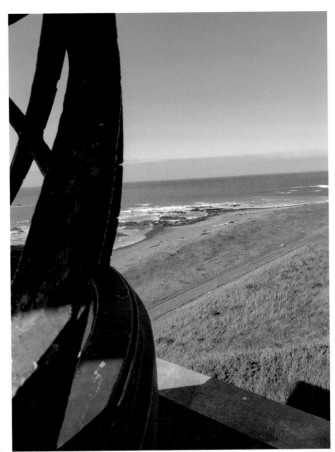

View from the deck outside
the lantern room. The railing is
already collapsing in some places.

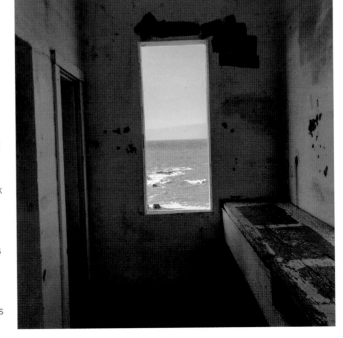

The downstairs watch room. The
keeper on duty would have spent
most of the night here. When not
refueling the light, trimming the
wicks, or rewinding the clockwork
weights which turned the lens,
keepers busied themselves
logging the weather, fuel
consumption, and notable events
of each night. When not actively
engaged with lightkeeping,
reading material was usually on
hand to entertain the lightkeepers
through the long nights.

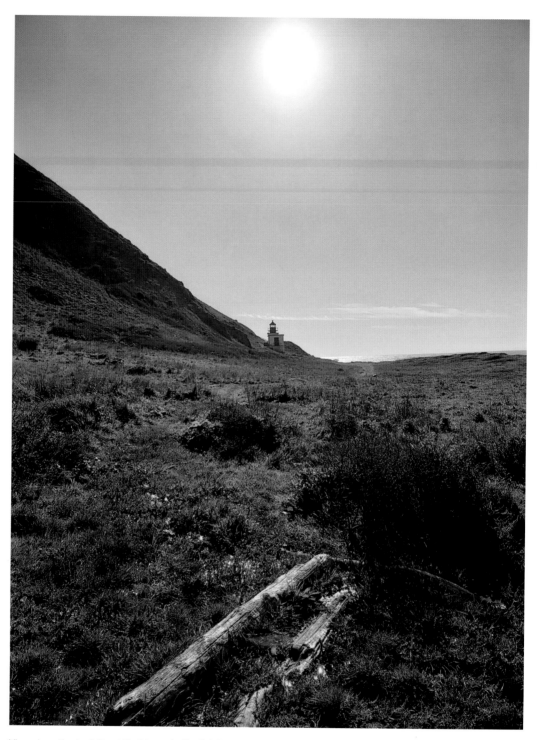

View along the Lost Coast Trail towards the lighthouse. The total isolation of the area cannot be understated, though the trail is quite popular during the warmer months on the north coast.

ABOUT THE AUTHOR

CLINT REQUA is a twenty-eight-year-old water treatment operator and connoisseur of the inadvisable. He has been an avid urban explorer for almost a decade, finding his way into long-abandoned mines and empty hospital corridors all over the Golden State. When he isn't inhaling the crisp, fresh air found only in the bowels of a Superfund site, Clint enjoys building and racing cars, swimming, hiking, reading, woodworking, and anything else that might keep a young man's mind distracted when he's too cheap to pay for cable. He lives in a small seaside town on the sunny Central Coast of California with his fiancée and their many cats.

BIBLIOGRAPHY

MONTARIOSO

"Paradise Lost at the Botanist's Mansion," MessyNessy.com, May 2018
"The Life of Dr. Francesco Franceschi and his Park," Pacific Horticulture Society,
 July 2002

BETTERAVIA

"Key Dates Regarding Betteravia, the Sugar Mill and the Railroad," Friends Of Santa
 Maria Valley Railroad. http://www.friends-smvrr.org/images/history/Betteravia-
 brochure.pdf
Middlecamp, D., "The Betteravia Sugar Plant Explosion of 1988," *The Tribune*,
 January 9, 2015

POLY CANYON

"Poly Canyon Design Village in San Luis Obispo," HikesPeak.com, https://www.
 hikespeak.com/trails/cal-poly-canyon-design-village-hike-san-luis-obispo
Logan, M. "Cal Poly's Largest Laboratory Is Being Renewed," *Mustang News*,
 February 17, 2015

RINCONADA MINE

Bradley, W.W., *Quicksilver Resources of California,* Sacramento, California State Printing Office, 1918
"Rinconada Mine," Weird California, http://www.weirdca.com/location.php?location=1006

FORT ORD

Fort Ord Reuse Authority, www.fora.org
"Historic California Posts, Camps, Stations and Airfields: Fort Ord," MilitaryMuseum.org, http://www.militarymuseum.org/FtOrd.html
"Fort Ord, California," Encyclopedia of Forlorn Places, http://eofp.net/fortord.html

DEVIL'S SLIDE & SF-51

Kinney, A., "Devil's Slide Military Bunker: That Strange Building Off Highway 1," *Mercury News,* November 23, 2015
"Cold War Era, 1952-1974," National Parks Service, https://www.nps.gov/goga/learn/historyculture/cold-war.htm
"Historic California Posts, Camps, Stations and Airfields: Milagra Military Reservation," MilitaryMuseum.org, http://www.militarymuseum.org/MilagraRidgeMilRes.html

SUTRO BATHS & LAND'S END

"Land's End History", National Parks Service, https://www.nps.gov/goga/learn/historyculture/lands-end.htm
"The Sutro Baths," Fog City Secrets, https://www.inside-guide-to-san-francisco-tourism.com/sutro-baths.html
"Octagon House At Land's End," OutsideLands.org, https://www.outsidelands.org
"Land's End Octagon House," Atlas Obscura, https://www.atlasobscura.com/places/lands-end-octagon-house-point-lobos-marine-exchange-lookout-station

PUNTA GORDA LIGHTHOUSE

Jones, R., *Lighthouses of California and Hawaii: Eureka to San Diego to Honolulu*, The Globe
Pequot Press (2002)
"Punta Gorda Lighthouse," LighthouseFriends.com, https://www.lighthousefriends.com/light.asp?ID=63
"Punta Gorda Lighthouse via Lost Coast," AllTrails.com, https://www.alltrails.com/trail/us/california/punta-gorda-lighthouse-via-lost-cost-trail